IMAGES
of America

IRISH
CHICAGO

Cover Image: These children are part of a 2,000-strong assembly of West Side Irish organizations who made a 1959 pilgrimage to Our Lady of Sorrows at Jackson and Albany for the basilica's novena. (Photo courtesy of Archdiocese of Chicago's Joseph Cardinal Bernadin Archives and Records Center.)

IMAGES of America

IRISH CHICAGO

John Gerard McLaughlin

ARCADIA

First Printed 2003.
Reprinted 2003.

Published by Arcadia Publishing,
an imprint of Tempus Publishing, Inc.
3047 N. Lincoln Ave., Suite 410
Chicago, IL 60657

Printed in Great Britain.

Library of Congress Catalog Card Number: 2002110453

For all general information contact Arcadia Publishing at:
Telephone 843-853-2070
Fax 843-853-0044
E-Mail sales@arcadiapublishing.com

For customer service and orders:
Toll-Free 1-888-313-2665

Visit us on the internet at http://www.arcadiapublishing.com

This work is dedicated to Frank Palella in appreciation for his constant good cheer, support, and encouragement.

CONTENTS

ACKNOWLEDGMENTS

I would like to acknowledge those whose scholarship in Chicago and Irish history has informed this project from beginning to end. Anyone wishing to delve into the subject further would do well to start with these authors: Timothy Barton, Nicholas Carolan, John Corrigan, Perry R. Duis, Eileen Durkin, Charles Fanning, Kathleen M. Flanagan, Michael F. Funchion, Paul Michael Green, Neil Harris, Suellen Hoy, Frank Kinahan, Emmet Larkin, Lawrence E. McCullough, Lawrence J. McCaffrey, Eileen M. McMahon, Janet Nolan, Thomas J. O'Gorman Dominic Pacyga, Ellen Skerrett, Sue Taylor, and Louise Carroll Wade.

I would also like to thank everyone who loaned photographs from their collections, invited me into their homes or inner sanctums, or offered advice: Rev. Conrad Borntrager OSM, Jane M. Byrne, Mary Kay Cappitelli, Patricia Clarke, Karen Crotty, Garnette Delaney, Brother Conrad Diebold, FSC, Mike Dooley, CPD, The Fahey Family, Jack and Mary Kate Fleming, Peter Foote, Kathleen Gaughan, John Gill, Anita Theresa Hayes, BVM, James Healy, Kevin Henry, Pat Hill, Jim Kane, Kathy Lux, Joe McGovern, Dan McLaughlin, Dayle Murphy, Rev. John McNalis, Tom Mescall, Brother P.J. Messick, CFC, Erin Molloy-Bauer, Jay Robert Nash, George and Mary Ellen Nedved, Joseph O'Shaughnessy, Deb Rapuano, Pat Slapinski, Ron Weslow, John Williams, and Rita Wogan.

Several institutions were also of great help during the course of this project: Julie Satzik at the Archdiocese of Chicago's Joseph Cardinal Bernadin Archives and Records Center; the Chicago Historical Society; Brian Donovan and Patty Nedved, Irish American Heritage Center; Elizabeth Oldroyd, Old St. Patrick's Church; Roberta Mezinskas and Kathleen Otto, Our Lady of Good Counsel Parish; Linda Lamberty, Ridge Historical Society; special thanks to Morag Walsh, Special Collections and Preservation, Harold Washington Library; Special Collections, The University Library, The University of Illinois at Chicago; Maureen Gill and Mark Howard, Trinity Academy of Irish Dance; Valerie Browne and Ann Ida Gannon, BVM, Women and Leadership Archives, Loyola University Chicago; and James Harney, Young Irish Fellowship Club.

Special thanks to Tim Hickey for his friendship, to Bill King and Noel Rice for their accessibility and generosity, and to my editor, Samantha Gleisten. Thank you to my family, especially Vicki O'Connell, Jim McLaughlin, and Michael McLaughlin.

Finally, dear readers, if you can identify anyone in these photographs, or add more to the story when the history of a particular picture has eluded us, please contact the publisher.

INTRODUCTION

For the Irish, Chicago's emergence as the nascent city on the prairie was timely. The construction of the Illinois and Michigan Canal, which would connect the Great Lakes to the Mississippi River, began in 1836, drawing Irish laborers who had helped build the great eastern waterways like the Erie Canal in the previous decade. The completion of the canal in 1848 coincided with the mass emigration from Ireland caused by the Great Famine. Over eight years, more than a million Irish entered the United States, many of them settling in the growing, opportunity-filled city of Chicago.

A good proportion of the early Irish immigrants were poor, unschooled, and unchurched, leading to social problems that alarmed the city's native population. In an oft-quoted outburst of bigotry, the *Chicago Tribune* argued that "the most depraved, debased, worthless and irredeemable drunkards and sots which curse the community, are Irish Catholics." The building of Irish-administered parishes like St. Patrick, St. Bridget, and Holy Family was an important step in helping to stabilize a community traumatized by the experience of famine and the disruption of emigration.

Like all immigrant groups hungry for success and acceptance, the Irish worked hard to overcome their initial disadvantages. The first waves toiled in the packinghouses, railyards, brickyards, gasworks, and mills; Irish women were employed in factories and as domestics. Being native English speakers and savvy to English-derived politics, they soon moved into municipal jobs like transit and the police and fire departments, and came to wield a political and pastoral influence beyond their numbers. Teaching, nursing, law, and medicine were other occupations for the upwardly mobile Irish of Chicago. In addition, Irish religious orders founded parishes, schools, hospitals, and charitable organizations that served Chicagoans of all religious and ethnic backgrounds.

Unlike other European groups who were tied to specific neighborhoods and institutions that helped preserve their language and culture, the Irish spread out all over the city, to the south, west, and north sides, building churches wherever they settled and creating stable parish-centered neighborhoods and political organizations. Although their percentage of the population in the city was continually decreasing in the late 19th and early 20th centuries, the Irish had a flair for local leadership that kept them in office. The Irish brand of ward politics was responsive to the needs of later immigrant groups arriving from Southern and Eastern Europe, and the shared Catholic faith of the Irish and the newcomers made each seem less alien

to the other. While the Irish had assumed leadership of the Catholic Church early on, they didn't consolidate their political power at the highest levels of city government until the 193Cs.

In the 19th century, Chicago's Irish remained engaged in the struggle for independence back home through involvement in organizations like Clan na Gael and the Ancient Order of Hibernians. Over time, the Americanization of succeeding generations and the eventual establishment of the Irish Free State in 1922 loosened these ties. With the nationalist struggle subsiding and fewer immigrants crossing the Atlantic, many feared for the loss of Irish culture in Chicago. However, the Catholic parish structure managed to create and maintain an Irish/American hybrid that required only ancestry to perpetuate itself, not "actual Irish"—to use Lady Aberdeen's term for the "lads and lasses" of the Irish Village at the 1893 Columbian Exposition. Nonetheless, it helped to have a reduced but steady flow of immigrants after World War II to breathe life into the Irish music and dance scene.

With the mass exodus to the suburbs over the last five decades, the majority of Irish in the Chicago area now live outside the city limits. Mayor Richard M. Daley acknowledges the transition, noting, "The heart of the old Southwest Side used to be at 63rd and Halsted...but now, it's at 159th and LaGrange [in Orland Park]. Things change. Nothing is what it used to be." Despite the worlds of difference, the old Catholic parishes and today's suburban neighborhoods share a certain homogeneity; and for the suburban Irish who participate enthusiastically in organizations like the Irish Children's Fund and the Trinity Academy of Irish Dance, the cultural bonds are as strong as ever.

<center>* * *</center>

To the many readers who are second, third, and fourth generation Chicagoans of Irish descent, the world portrayed in this volume is likely to be distant. It is a world where Friday novenas on the West Side had the power to draw 60,000 faithful regularly. A world of unlikely geography, where a Robert Emmett Memorial Hall could exist at Ogden, Taylor, and Leavitt, or a Gaelic Park at 47th and California. A world of streetcars, Saturday and Sunday night dances across the city, and torchlight parades for the cause of Irish freedom.

This book is an attempt to create a photo album for the approximately one million people with Irish ancestry in the Chicago area. It is hoped that the pictures within will hold something for everyone. For the Irish immigrant recently arrived in Chicago, it may be a look back at the accomplishments and ways of those who came before. For the fourth generation Irish American suburbanite whose only link to heritage may be an Irish surname, it is meant to be a reminder of the rich past that subtly but certainly defines everyone whose ancestors settled here.

One

THE EARLY YEARS

The earliest Irish settlements in the city were situated along the Chicago River. Hardscrabble, later known as Bridgeport, was located on the river's south branch; Kilgubbin, named for the residents' home village in Cork, was along the north branch; and the third settlement was just west of the river around Adams and DesPlaines, where Old St. Patrick's church now stands. The success of the Illinois and Michigan Canal, built with Irish labor, spurred the growth of trade and industry and brought more jobs and more Irish to Chicago. By 1850, one-fifth of the city's population was Irish born.

Life was not easy for the early Irish immigrants. Many were refugees from famine, escaping the fate of certain starvation for a life of hard work on a strange, raw frontier. They dug, lifted, and carried, and eventually worked their way up and out of their original communities. Out of the devastation of the Great Fire of 1871 came the opportunities and challenges of rebuilding the city. The Irish work force was central to Chicago's reconstruction and to the development of the industries that would make the city famous: its stock yards and railroads.

The early city was much smaller than it is today. In 1869, the borders were 39th Street to the south, Fullerton to the north, and Pulaski to the west. At the time of Patrick McDonnell's birth in 1842, the area where he grew up between Western, California, and the river was woodlands, prairie, and small farms. McDonnell's father had helped to build the canal, but stayed on to become a rural justice of the peace and to grow corn and make hay. Likewise, when St. Gabriel parish was founded in 1880, the Canaryville neighborhood was in the town of Lake, not Chicago. The annexation of towns to the north (Jefferson and Lake View) and south (Lake and Hyde Park) in 1889 and the subsequent construction of elevated lines across the city opened new areas for settlement, and the Irish dispersed throughout Chicago.

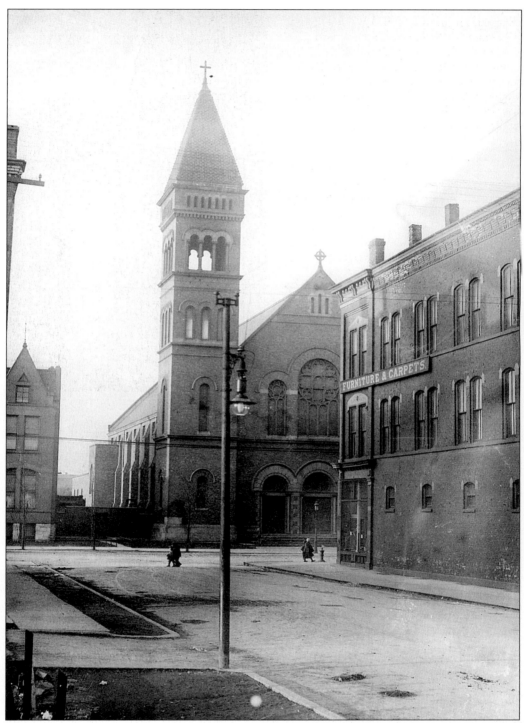

Founded in Bridgeport in 1850 to serve the Irish builders of the Illinois and Michigan Canal, St. Bridget on Archer Avenue survived the construction of the Stevenson Expressway, only to fall to the wrecker's ball in 1992—a piece of Chicago Irish history lost forever. (*Daily News* photo courtesy of Chicago Historical Society, DN-0056541.)

The pastoral hillside of St. James Cemetery in Lemont is the final resting place for some of the Chicago area's first Irish immigrants, who migrated to the region during the construction of the Illinois and Michigan Canal (1836–1848). Epidemic diseases like cholera, influenza, and smallpox took a heavy toll on early settlers.

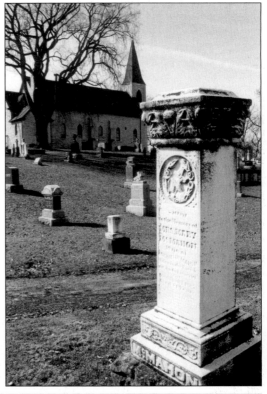

Patrick and Elizabeth McDonnell and 10 of their 12 children pulled up the oriental rugs for a family portrait in front of their Brighton Park home around 1900. The son of a Kildare man who came to Chicago to build the Illinois and Michigan Canal, McDonnell, born in 1842, remembered walking across the canal bottom before it was first filled in April 1848. To say that McDonnell witnessed great changes in the city during his lifetime is an understatement: in the span of his 97 years, the population of Chicago grew from five thousand residents to nearly three and a half million. (Photo courtesy of Karen Crotty.)

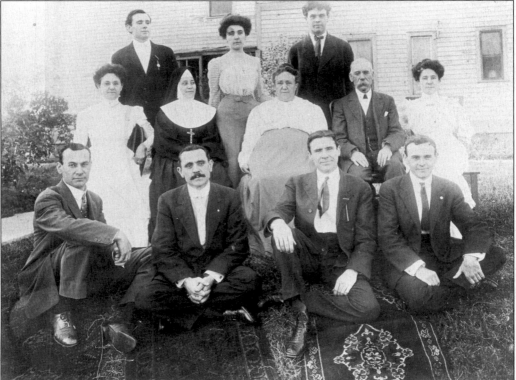

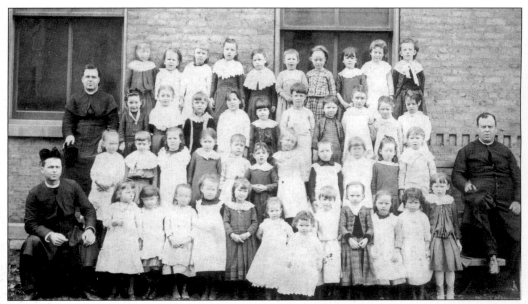

Father Maurice J. Dorney (right) poses with female students of St. Gabriel School. Dorney presided over the Canaryville parish from its founding in 1880 until his death in 1914. Known as "The King of the Stockyards," Dorney mediated disputes between workers and packinghouse owners, advocated temperance in an area overrun with taverns, and as a member of the nationalist group Clan na Gael, took an active role in the fight for Irish independence. (Photo courtesy of St. Gabriel Parish.)

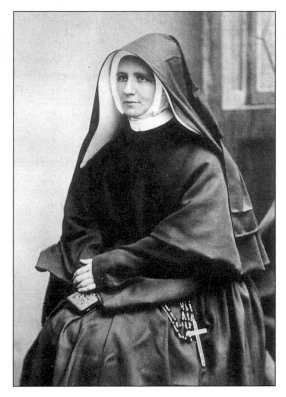

Sister Mary Agatha Hurley, BVM, led a small group of Irish nuns from Dubuque, Iowa, to Chicago in 1867 to establish schools for the burgeoning Holy Family Parish on the West Side. Besides the schools of Holy Family, which together enrolled more than four thousand children, Hurley established schools at Chicago parishes St. Pius, St. Bridget, St. Vincent DePaul, and St. Charles Borromeo. In later years, The Sisters of Charity of the Blessed Virgin Mary were also responsible for establishing, among other institutions of learning, Immaculata High School and Mundelein College. (Photo courtesy of the Sisters of Charity BVM Archives.)

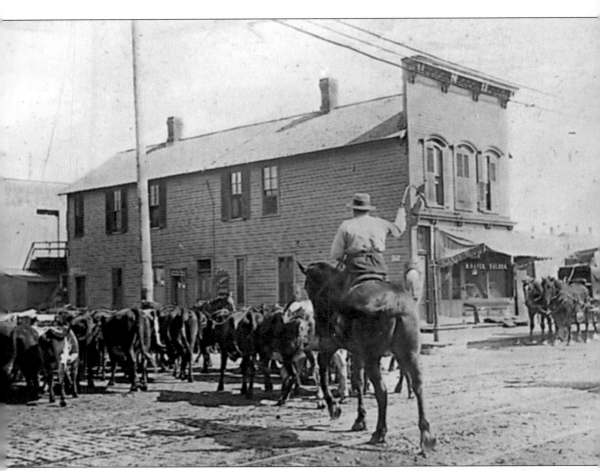

The Irish were among the first of succeeding waves of immigrant laborers to earn their livelihoods at the Union Stock Yards, located between Ashland and Halsted from 39th to 47th Streets. In this 1880 photo that could easily pass for a snapshot of the Old West, a drover herds his cattle to the yards over streetcar tracks and past Hayes Saloon. (Photo courtesy of Special Collections and Preservation Division, Chicago Public Library.)

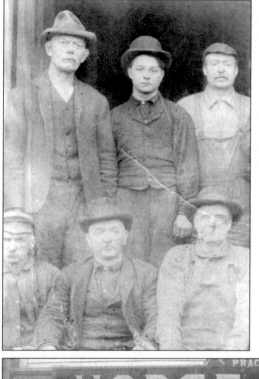

In the aftermath of the Great Fire of 1871, the industries in the heavily-Irish Bridgeport area were crucial to the rebuilding of the city. The Union Stock Yards and packinghouses prospered, and the South Branch of the river was home to brickyards, rail yards, lumberyards, and iron and steel mills. Mr. Mooney (bottom center) and William Dunlop (top left) were among the Irish workers of a local steel mill. (Photo courtesy of Our Lady of Good Counsel Parish.)

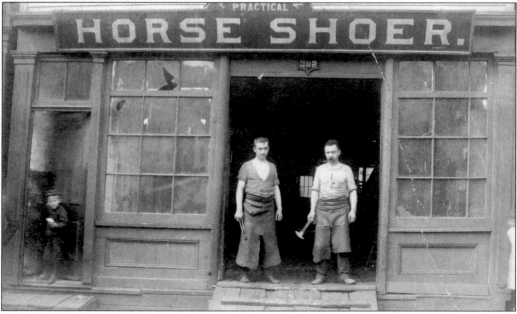

Frank Doran (right) was born in the tough Irish parish of St. John (18th and Clark) in 1867. He was baptized by the legendary pastor Rev. John Waldron, a man who patrolled the streets of the parish at night armed with only his moral authority and a blackthorn stick to protect him. As an adult, Doran lived and eventually died by his trade of horseshoeing, succumbing to internal injuries caused by a horse kick in 1903. The funeral procession from St. Jarlath's Church on the West Side to Mount Olivet Cemetery on 111th Street was about 15 miles—a considerable distance in the days of horse drawn carriages. (Photo courtesy of Pat Slapinski.)

Kerry-born William A. Cahill stands at a press in his printing company at Adams and DesPlaines, across the street from Old St. Patrick's. Although he grew up a member of St. Columkille parish, Cahill was familiar with St. Patrick's. On the Monday afternoon of the Great Fire in 1871, when he was 16, Cahill became separated from his parents and took refuge in the church quarters until he could go home again. Twenty-five years later, he opened his press across the street, where it remained until the family relocated the business in 2001. (Photo courtesy of Cahill Printing Company.)

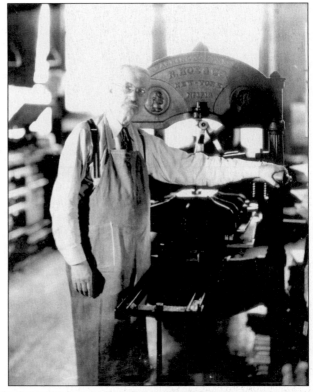

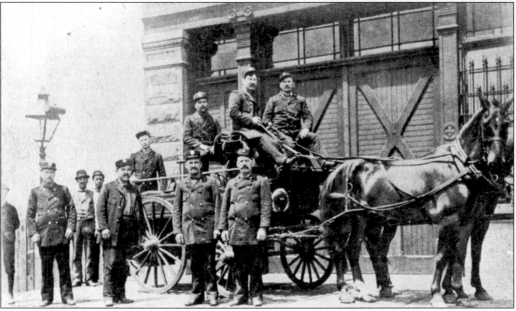

The firemen of Engine Company 39 pose with their horse-drawn hose wagon in 1893. Standing, from left to right, are J.J. Kelly, Ernest Pannier, William Wilson, Lieutenant Dennis Doyle. On the wagon: Joseph O'Connell, Jeremiah Trumbley, driver Edward Sweeney, and Captain Patrick Foley. The station, located at 33rd and Ashland, is still in use. (Photo courtesy of the Fire Museum of Greater Chicago.)

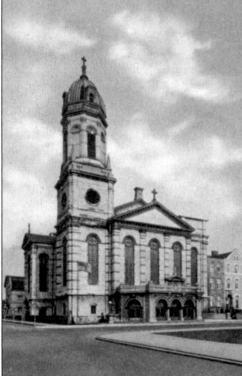

Catherine and Patrick O'Leary of 137 DeKoven Street on the West Side became unwitting celebrities when a fire that began in their barn on October 8, 1871, engulfed the city and left 100,000 residents homeless. The most enduring legend blames Mrs. O'Leary's cow for kicking over a lamp and starting the blaze, but the true cause remains unknown. Other fanciful tales connected to the night of fire include fiddlers and peg-legged characters with names like Sullivan, McLaughlin, White, and Regan. (Photo courtesy of Special Collections and Preservation Division, Chicago Public Library.)

St. Columkille at Grand and Paulina was one of the earliest Irish parishes in the city. Founded in 1859, the church was named for the 6th-century Irish saint who established monasteries all over Ireland. It is said to have been a refuge for clerics fleeing the Chicago Fire of 1871. The church was closed in 1975 and later demolished. (Photo courtesy of Jim Kane.)

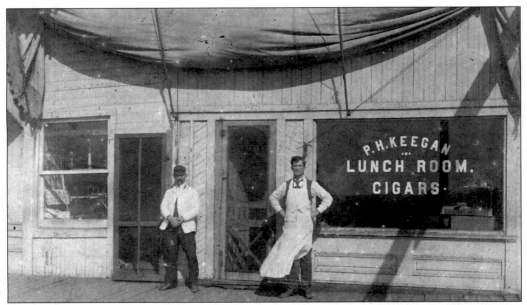

Proprietor P.H. Keegan poses outside his lunchroom and saloon, located at 3854 W. Madison, in 1891. In early Irish saloons, whiskey was the drink of choice. Gradually, in part because of the strong German influence in Chicago, beer found popularity with the Irish in Chicago, and Irish brewers like John S. Cooke and the Fortune brothers capitalized on the changing tastes of their countrymen. (Photo courtesy of Special Collections and Preservation Division, Chicago Public Library.)

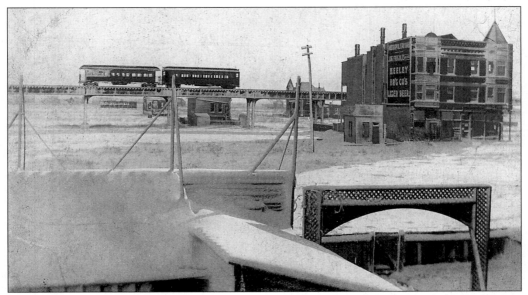

A Garfield Park elevated train passes through the snow-covered, sparsely settled neighborhood around Harrison and Kostner in 1895. The building to the right carries an advertisement for Keeley Brewing Company's Lager Beer. Michael Keeley, an immigrant from Carlow, founded the company in 1876 after purchasing a brewery at 28th and Cottage Grove. The brewery remained in the family until the beginning of Prohibition. (Photo courtesy of Special Collections and Preservation Division, Chicago Public Library.)

DIPLOMA

Irish History Scholarship
FOR
PAROCHIAL SCHOOLS

THIS IS TO CERTIFY THAT

Miss Marie Veronica Moloney

A pupil at *Our Lady of Sorrows* Parochial School, Chicago, in the *Eighth* grade has completed the course in **Irish History** and passed a satisfactory examination therein; and in recognition thereof *she is* awarded this diploma of merit by the County Boards of the

Ancient Order of Hibernians and Ladies' Auxiliary
OF COOK COUNTY, ILLINOIS

In Witness Whereof these presents are signed by the County Presidents of the Ancient Order of Hibernians and Ladies' Auxiliary of Cook County, Illinois, and the seal of the Cook County Board A. O. H. is affixed this *eighteenth* day of June, A. D. 190 *1*.

Rev. M. O'Sullivan
County Chaplain

Wm. J. Doherty
County President, A. O. H.

Mary F. McWhorter
County President, Ladies' Auxiliary A. O. H.

Graduate Marie Veronica Moloney of Our Lady of Sorrows School was awarded the diploma above by the Ancient Order of Hibernians in 1908 for successfully passing a course in Irish studies. Mary F. McWhorter, the president of the Cook County Ladies Auxiliary of the Ancient Order of Hibernians and one of the diploma's signatories, considered Irish history essential to the cultural development of Irish-American children. In a scathing attack on the Irish Revival plays of the Abbey Theatre, in which she confessed an "insane desire" to commit murder against co-founder Lady Gregory, McWhorter suggests a remedy to the theatre's calumnies: "Place a little history of Ireland in the hand of each little boy and girl of the ancient race, and all the Lady Gregories in the world will not be able to destroy an atom of our splendid heritage." (Photo courtesy of Our Lady of Sorrows Parish.)

Two

FAMILY LIFE

In *The Irish in Chicago*, historian Lawrence J. McCaffrey points out that among European immigrants, the Irish were distinctive in that they came in roughly equal numbers male and female, and were overwhelmingly single. Irish newcomers, once settled, often helped other family members make the journey across the Atlantic. Policeman Patrick Delaney not only paid his brother's passage from Tipperary to Chicago, he helped him secure a job on the police force. Irish women in particular were highly employable, especially in jobs that other ethnics shunned for cultural reasons, like domestic work. Mary Maeliff Wogan, whose photo appears in this chapter, immigrated with her sister and spent her entire working life in "the great houses," according to her daughter-in-law Rita Wogan. After being widowed, Maeliff Wogan raised her sons on her own and lived frugally enough to eventually purchase a home on the West Side.

McCaffrey adds that once married—a pleasant consequence of the weekly ritual of attending the popular Irish dances—Irish women were more likely to leave the workplace and manage family life. Given the size of many Irish families of earlier generations, this was no easy task. In turn-of-the-century Bridgeport, Michael and Lillian Daley were an anomaly among Irish families of the neighborhood because they had only one child, Richard J. Daley. Families the size of Police Chief Francis O'Neill's—he and his wife, Anna, had ten children—were more common, although only four of the O'Neill children survived into adulthood in a time of high child mortality rates. Families were aided in what McCaffrey calls the "slow but tenacious Irish drive toward middle-class respectability" by their association with the Catholic Church. Catholic families were expected to send their children to the parish schools, and the Irish did so in higher numbers than any other ethnic group. Despite the sacrifice, the schools helped to create a parish community that strengthened and enriched individual Irish families.

Looking nicely kitted out in their hand-knit and woven Donegal woolens, the Thomas Gibbons family of Madison Street model fashions imported for the 1958 Irish *Feis* held at Pilsen Park. (Photo courtesy of Archdiocese of Chicago's Joseph Cardinal Bernadin Archives and Records Center.)

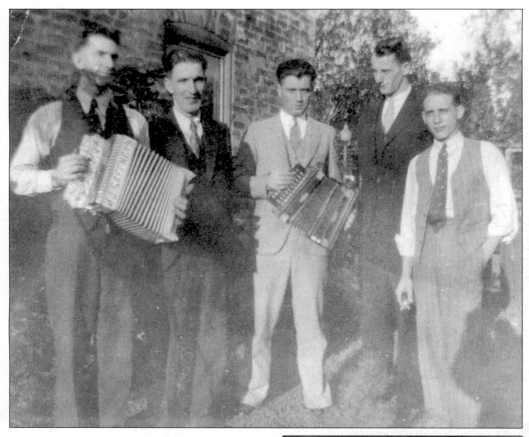

When Pat Finnegan (center) immigrated to the United States from Williamstown, Galway, in the early 1920s, he was a man with a price on his head. His involvement with the rebel forces during the Anglo-Irish war of 1919–1921 left him with little choice but to flee to the safety of an uncle in Chicago. He soon sent for his two sisters, Mary and Ann (below, flanking Finnegan), and before long he was settled into a new life here, eventually marrying and raising a family. Recently, when an old Chicago friend was asked whether she knew of Finnegan's IRA past, she neither admitted nor denied knowledge of it, only saying, 'We never talked about those kinds of things.' (Photo courtesy of Kathy Lux.)

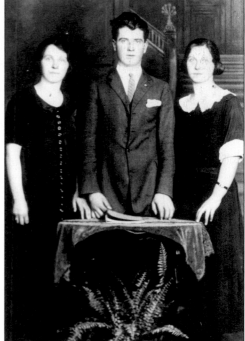

On the day of her son William's wedding in 1943, Mary Maeliff Wogan had much to celebrate. She emigrated from County Offaly in 1905 with her sister Katie and worked off the cost of her passage on an Iowa farm. Several years after moving to Chicago, she met Thomas Wogan at an Irish dance and the two married, but Mary was widowed shortly after the birth of her second son. She raised both boys on her own, eventually saving enough money from her job as a housekeeper to buy a home near Monroe and Laramie. In this photo, she is flanked by her sons William and Thomas. (Photo courtesy of Rita Wogan.)

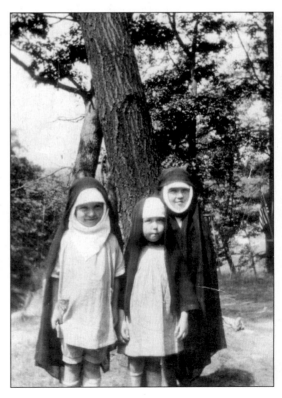

It was never too early to get children started thinking about vocations. Inspired by their older cousin Sister Delmacia, sisters Rita, Evelyn, and Dolores Oates enjoyed a day of dressing up as nuns at their parents' Cedar Lake, Indiana summer home around 1925. (Photo courtesy of Rita Wogan.)

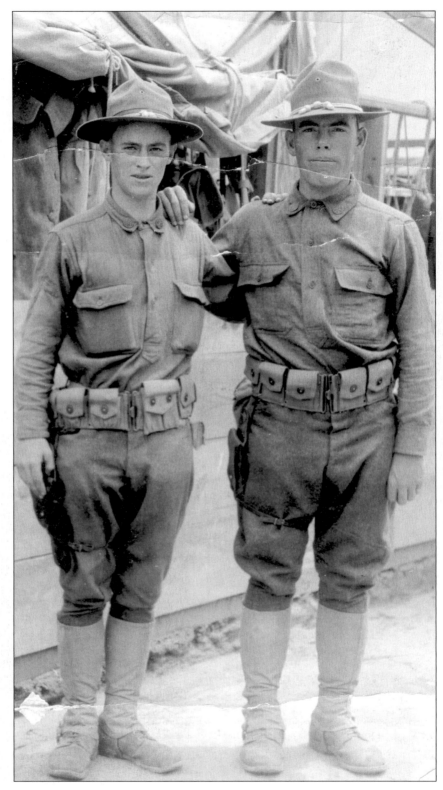

First generation Americans Bert and John McInerney both served in France during World War I—John lied about his age so he could join his older brother. John documented his war experience with frequent letters home and long reflective poems. (Photo courtesy of Pat Slapinski.)

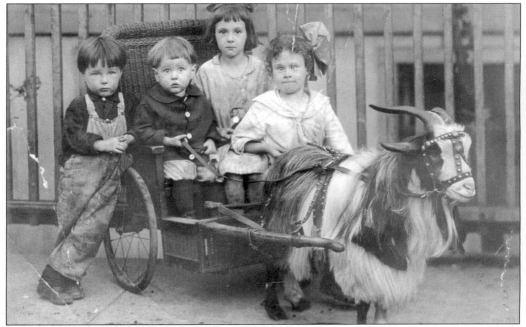

Johnny, Charlie, Margaret, and Eleanor McGorey pose with a neighborhood curiosity, a goat-drawn carriage for children, in front of their West Side home around 1915. (Photo courtesy of Rita Wogan.)

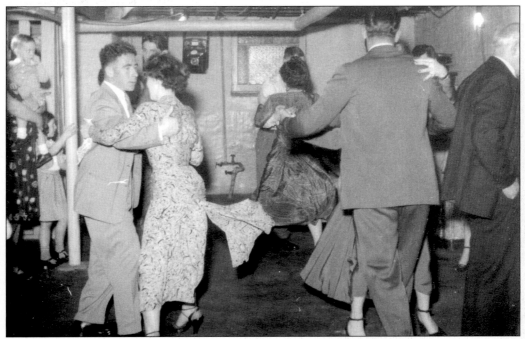

Johnny Hughes and Jeannie Duffy (left) cut a rug at the 1948 wedding reception of Kathleen and Francis Gaughan. The festivities were held at the bride's parents' home on 77th and St. Lawrence and went on into the wee hours. The Gaughans went on to raise five children. (Photo courtesy of Kathleen Gaughan.)

What more likely destination for a young Irish couple on a date in 1934 than a trip to the Irish Village at the Century of Progress World's Fair? Walter Philbin and Katherine Keane pose on a wagon with the faux Irish countryside in the background. The couple married a few years later. (Photo courtesy of Mary Kay Cappitelli.)

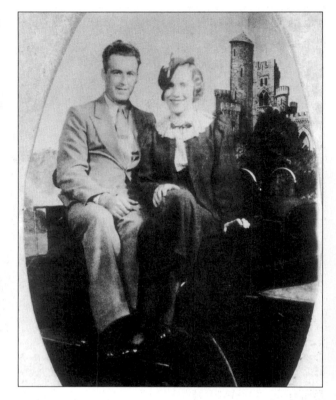

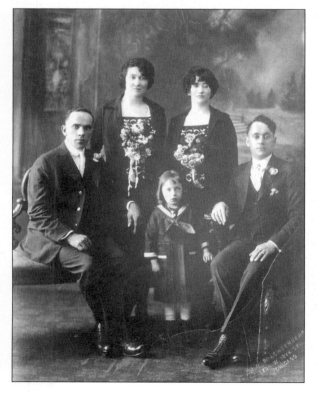

Newlyweds Daniel Murphy and Margaret Nolan (left) pose for a wedding portrait with witnesses Mary Nolan and Thomas Murphy. The child is unidentified. The marriage took place on October 23, 1924, at Most Precious Blood Church on the West Side. The Murphys and Nolans were from County Mayo. (Photo courtesy of Dayle Murphy.)

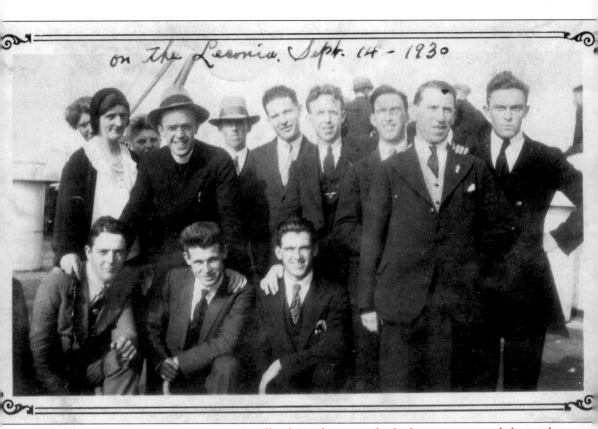

on the Laconia. Sept. 14 - 1930

The Atlantic crossing was an emotionally charged journey for Irish emigrants, and those who struck up friendships on the several days' voyage often kept in touch long after they reached their final destinations. Patrick Gill (kneeling, center) and Father Lavin (behind, in hat), who met on the *Laconia* in 1930, corresponded by post on and off into their senior years. At the time of this snapshot, Gill was coming to meet his sisters in Chicago, while Father Lavin was headed to a teaching assignment out West. (Photo courtesy of the Gill family.)

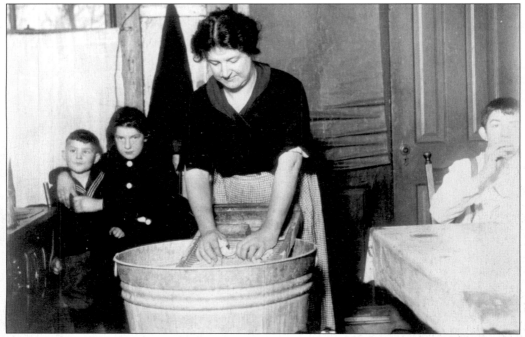

As her daughter and son regard the camera with a mixture of wariness and indifference, Mrs. Lynch gets on with her clothes washing in their near West Side home. (Photo courtesy of Department of Special Collections, The University Library, University of Illinois at Chicago.)

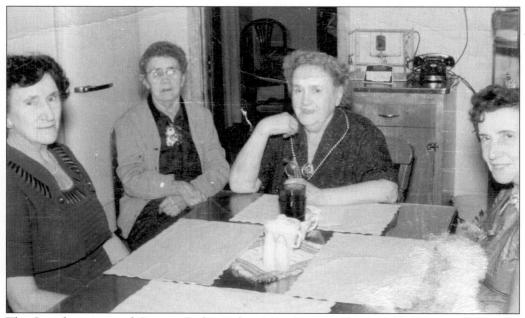

The Saunders sisters of County Cork—Helen, Mary Francis, Nora, and Lillian—gather in the kitchen at 78th and Wabash in 1957. The sisters grew up in a household of 26 children (including four sets of twins), all of the same two parents. In an era of small families and delayed parenting, the sisters' grandchildren and great-grandchildren never fail to elicit gasps of disbelief from listeners when they share this bit of family history. (Photo courtesy of George Ferguson.)

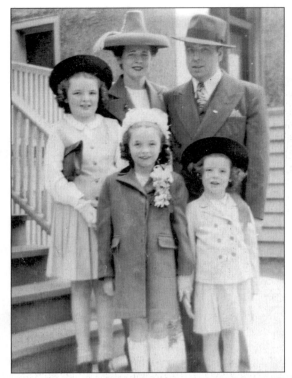

When James Delargy of Ballyvoy, Antrim, arrived in Chicago in April 1924, he had $120 in his pocket and the promise of a job at his uncle John O'Connor's paint store at Madison and Sangamon. By the time this Easter photo was taken in the early 1950s, Delargy and his wife, Margaret, were leading comfortable lives in the Austin neighborhood with their children Maureen, Margaret Ann, and Darlene. (Photo courtesy of the Gill family.)

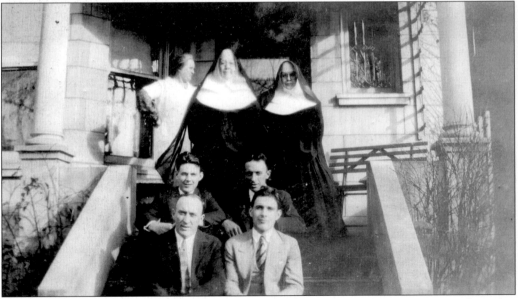

"Everybody wanted their picture taken with the Sisters," says Tom Mescall, leafing through a musty black photo album from the 1920s and pointing to nearly three pages of different family members taking their turn to pose with visiting aunt Sister Zita and her companion. In this photograph, taken at the Mescall home at 78th and Sangamon, are representatives of three occupations popular with the Irish in Chicago: from left to right, front to back, policeman Jim Mescall, fireman Tom King, policeman Larry King, Pete Mescall, Loretto Mescall, Sister Zita, and companion. (Photo courtesy of Tom Mescall.)

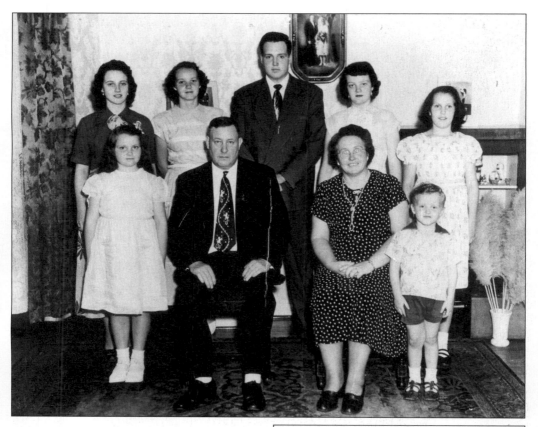

Galway natives Bartley and Mary Connolly and their children pose for a family portrait at their home in St. Margaret of Scotland parish in 1950. Knowing that her son's conscription into the armed forces for the Korean War was imminent, Mrs. Connolly assembled the family for their first-ever group photo. The parents' wedding portrait hangs on the wall in the background. (Photo courtesy of Kathy Lux.)

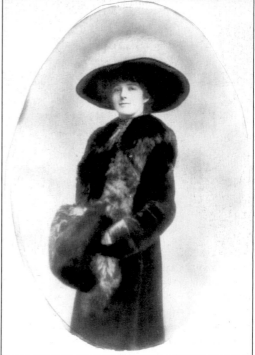

This portrait of Mary Clarke, taken in Chicago around 1908, caused quite a stir when its subject returned to her rural Galway home for a visit a few years later. The furs and plumage were donned as proof of the village girl's success in America. Booked to return to the U.S. on the *Titanic* in April 1912, Clarke postponed her travel date at the urging of relatives, who decades later remained convinced that their intervention was an act of providence. (Photo courtesy of Kathleen Gaughan.)

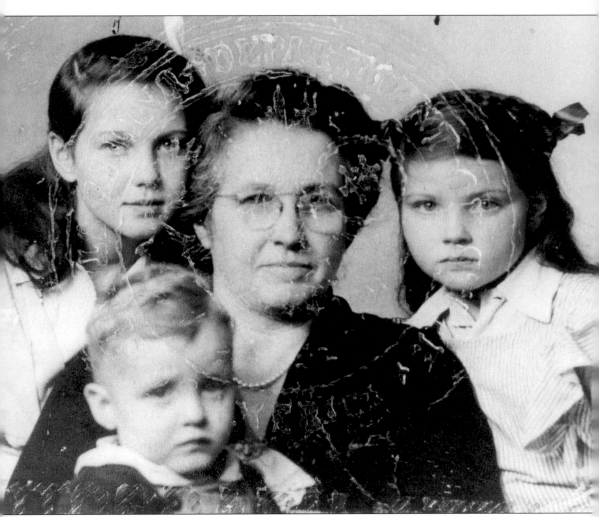

In the years before the daily Aer Lingus 7:40 p.m. flight to Dublin, the journey to Ireland from Chicago often lasted as long as an entire vacation by today's standards. Kathy Connolly Lux (top left, in a stamped family passport photo) remembers her 1949 visit to Ireland with her mother, Mary, and siblings Michael and Betty: "We boarded a train for New York at 63rd and State, and from New York sailed for five days on the converted warship SS *Washington*. From Cobh we took another train to Castlerea in Roscommon, where a horse and buggy collected us for the final leg of our journey to Listhomasroe." It was mother Mary Connolly's first trip back since she emigrated in 1925. (Photo courtesy of Kathy Lux.)

Three

IRISH CATHOLICISM

Long before the vogue of hyphenation to define one's place in America, Irish Catholic immigrants were distinguished by their religion. Not all Irish immigrants were Catholic, of course; in the 18th century, Ulster Presbyterians settled in the eastern part of the country in great numbers. In Chicago, however, the majority of the Irish who came during and after the Famine were rural Catholics. According to author Ellen Skerrett, who has written extensively about Catholicism and Chicago's Irish, Catholicism was a unifying force for an immigrant group that was often divided on matters of nationalism or politics. In the beginning, the Church was an institution to which impoverished newcomers could turn for stability and fellowship. In later years, when the Irish began to move into neighborhoods where Catholics were a minority, the parish became a focus of Irish middle-class aspirations.

Traditionally, the Irish have always played a role in the leadership of the Church in Chicago. From the appointment of the first bishop in 1844, until the installation of Archbishop Mundelein in 1916, the archdiocese was led by Irish prelates (with the exception of Belgian-born Bishop Van de Velde). Since parishes in the city were organized according to nationality and language as well as territory, the Irish were the majority in all of the English-speaking churches. Based in part on the early anti-Catholic orientation of the public schools, church hierarchy began to push for the establishment of parish schools. Parish schools, administered by religious teaching orders, were one reason for the strong identification of Catholicism with the Irish. In her essay, "The Catholic Dimension" from *The Irish in Chicago*, Skerrett explains that while other ethnic groups used parish schools to preserve language and culture, "the Irish established schools as a means of strengthening their Catholicism" and promoting an American Catholic identity.

The Irish also participated enthusiastically in the great Marian devotional movements of the 20th century. Rev. James R. Keane established a Friday novena at Our Lady of Sorrows Basilica in 1937 that at its peak of popularity drew 40,000–60,000 attendees each week, a great percentage of them Irish. Other parishes also established novenas and instituted May processions in honor of the Virgin Mary that became the highlight of the church year, particularly in heavily Irish parishes like Visitation on Garfield Boulevard.

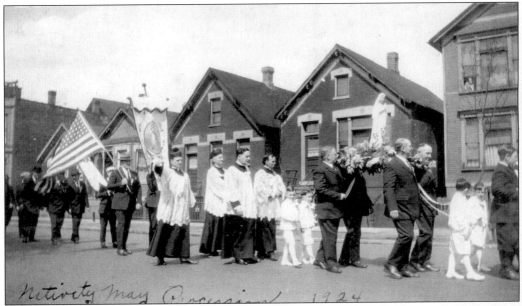

Nativity May Procession 1924

In the early part of the last century, Nativity of Our Lord Parish in Bridgeport held two May Processions, one conducted by the men of the Holy Name Society, and the other sponsored by the women of the Altar and Rosary Society.

Altar boys from Nativity of Our Lord parish gather before the 1924 men's May Procession. (Photo courtesy of Tom Mescall.)

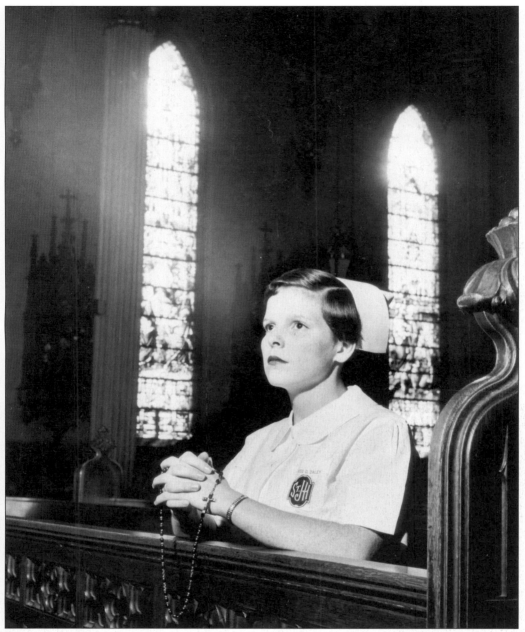

During the especially devout decades of the late 1930s through the 1950s, many occupations had a devotional association that represented the profession at religious events. In this photo, Miss D. Daley of St. Joseph Hospital promotes the annual Nurses Day Parade and Novena. (Photo courtesy of Our Lady of Sorrows.)

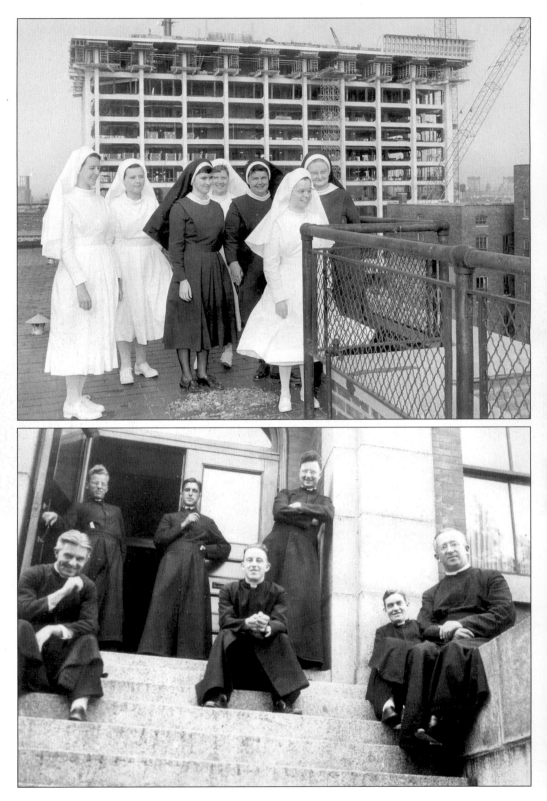

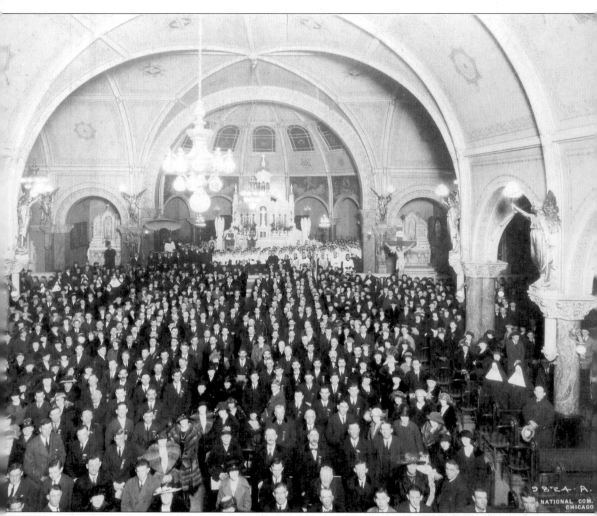

An overflow crowd faces the choir loft for a photo at the 1922 dedication of new altars at St. Gabriel church, 45th and Wallace. In keeping with the parish's strong Irish identity, the main altar of the landmark Burnham and Root church was embellished with a pattern of green mosaic tiles in the shape of shamrocks. (Photo courtesy of St. Gabriel Parish.)

Opposite, Top: Sisters of Mercy stand atop the old Mercy Hospital as the new rises in the background in 1966. Founded in Dublin by Catherine McAuley, the Sisters of Mercy religious community in Chicago was established in 1846 by a band of young Irish nuns. The order's longstanding commitment to education and health care has been of immeasurable benefit to generations of Chicagoans. (Photo courtesy of Sister Benjamin Watts, RSM.)

Opposite, Bottom: These young and dynamic Irish Christian Brothers were among members of the order who educated students at Leo, Brother Rice, and St. Laurence High Schools over the years. Pictured here, from left to right, are Brothers Breen, Lyons, Sullivan, Murphy, Enright, Shannon, and O'Connell. (Photo courtesy of the Congregation of Christian Brothers.)

35

One of the biggest events of the year at Visitation Parish, Garfield Boulevard and Peoria, was the May Crowning. At the Mother's Day 1937 crowning pictured above, Betty Jane Murphy, flanked by beaming grammar school handmaidens, was awarded the honor of laying the floral crown on the statue of the Blessed Mother. (Photo courtesy of Archdiocese of Chicago's Joseph Cardinal Bernadin Archives and Records Center.)

By 1953, the pomp and formality of the annual spring May Crowning ceremony at Visitation drew thousands of faithful and required the closing of Garfield Boulevard. Wearing a bridal gown and flanked by classmates, Norie Smith lays a wreath on a statue of the Virgin Mary. (Photo courtesy of Archdiocese of Chicago's Joseph Cardinal Bernadin Archives and Records Center.)

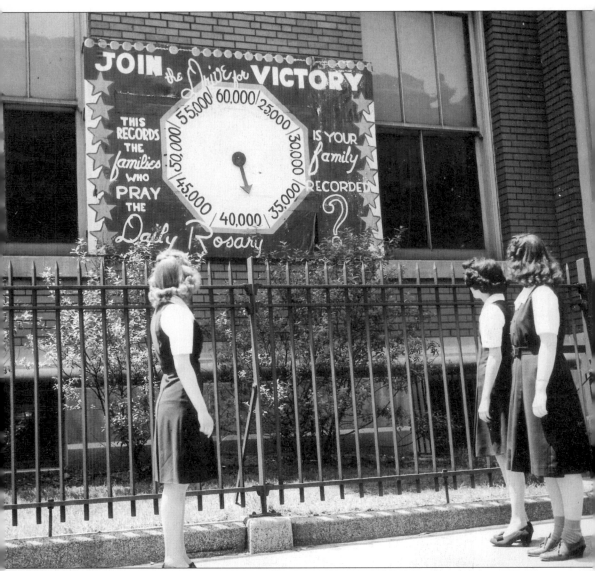

In Catholic parishes like Visitation, praying the Rosary was considered as essential to a World War II victory as troops and artillery. The Rosary Crusade Clock on Visitation High School recorded the number of area families committed to the daily devotional wartime effort. This photograph appeared in the *New World* newspaper in July 1943. (Photo courtesy of Archdiocese of Chicago's Joseph Cardinal Bernadin Archives and Records Center.)

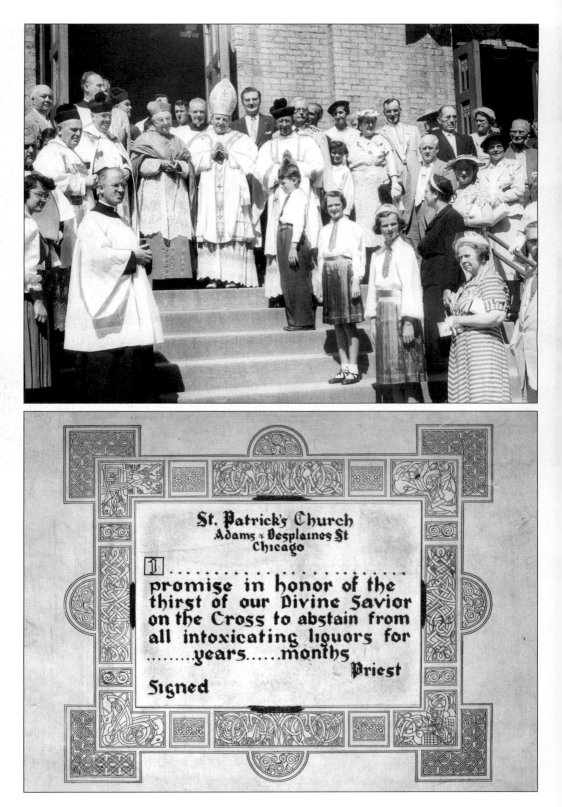

St. Patrick's Church
Adams & Desplaines St
Chicago

I..................................

promise in honor of the
thirst of our Divine Savior
on the Cross to abstain from
all intoxicating liquors for
........years......months

Priest

Signed

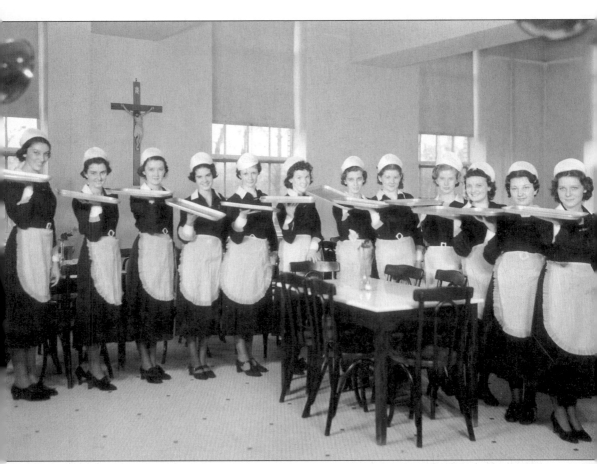

Mercy High School girls strike a Busby Berkely-esque pose in preparation for serving 1,500 CISCA (Chicago Inter Student Catholic Action) delegates at a citywide convention held at the school in 1936. (Photo courtesy of Archdiocese of Chicago's Joseph Cardinal Bernadin Archives and Records Center.)

Opposite, Top: For more than a century, St. Patrick church at Adams and DesPlaines has been the spiritual center of Chicago's Irish-Catholic community. In this 1954 photo, Samuel Cardinal Stritch (center left) and Auxiliary Bishop John Cody (center right) preside over the 67th annual convention mass of the Ancient Order of Hibernians. (Photo courtesy of Archdiocese of Chicago's Joseph Cardinal Bernadin Archives and Records Center.)

Opposite, Bottom: Along with the growing popularity of the American tavern as a meeting place sprung temperance movements that called for abstinence from liquor. A group familiar to the Irish in Chicago would have been the Pioneer Total Abstinence Association of the Sacred Heart, formed in Dublin in 1898 by Rev. James Cullen, S.J. This promise to abstain from alcohol, given before a priest, was referred to as "taking the pledge" and was meant to signal a devotionally-driven commitment to give up drink. (Photo courtesy of Historical Archives of Old St. Patrick's Church.)

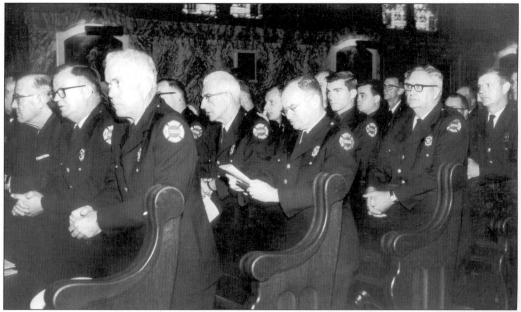

Chicago firemen attend the annual Memorial Day mass at Resurrection Church at Jackson and Leamington in 1967. That year's mass had added significance because it was celebrated by the newly-ordained Rev. James Tansey, the son of a fireman. (Photo courtesy of Archdiocese of Chicago's Joseph Cardinal Bernadin Archives and Records Center.)

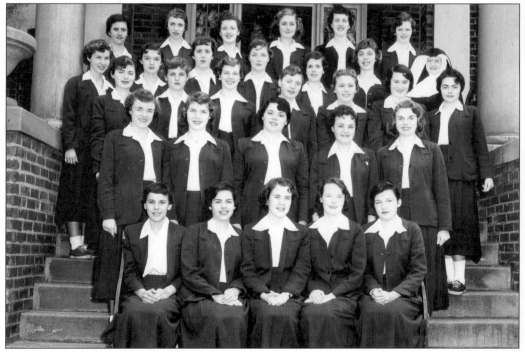

A sophomore class poses outside the Academy of Our Lady, 95th and Throop, in 1955. Administered by the School Sisters of Notre Dame, Longwood—as it was popularly known— was considered a prestigious school for girls on the South Side. (Photo courtesy of Kathy Lux.)

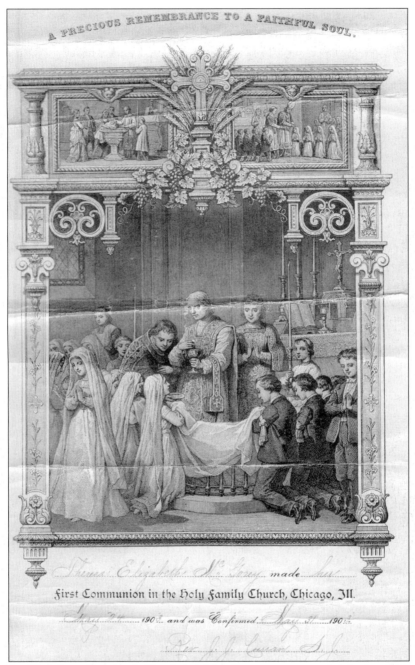

Theresa Elizabeth McGorey made her

first Communion in the Holy family Church, Chicago, Ill.

_____ 1903 and was Confirmed _____ 1903

Holy Family Church at Roosevelt Road and May Street was once the largest Irish parish in Chicago, with a congregation of 20,000 parishioners and some 4,000 students enrolled in its schools. Although Theresa Elizabeth McGorey, the recipient of the remembrance above, made her First Communion and Confirmation at Holy Family in 1903, her family soon joined the Irish migration to parishes further west. Holy Family Church came close to being demolished in the mid-1980s, but a popular outcry from former parishioners and preservationists (it was one of only a few public buildings to escape the Great Fire of 1871) led to its restoration instead. (Photo courtesy of Rita Wogan.)

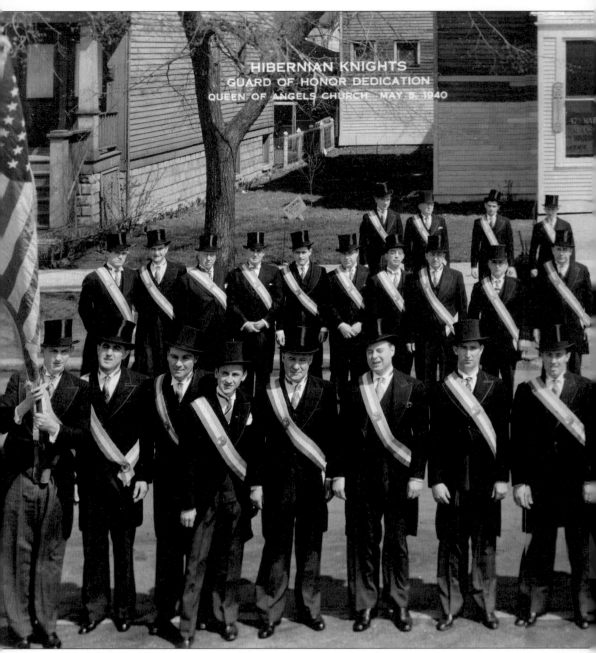

The elegantly-attired honor guard of the Ancient Order of Hibernians turned out in force for the 1940 dedication of the new Queen of Angels Church at Claremont and Sunnyside. Unlike parishes to the south, St. Andrew and St. Benedict, with their respective Irish and German

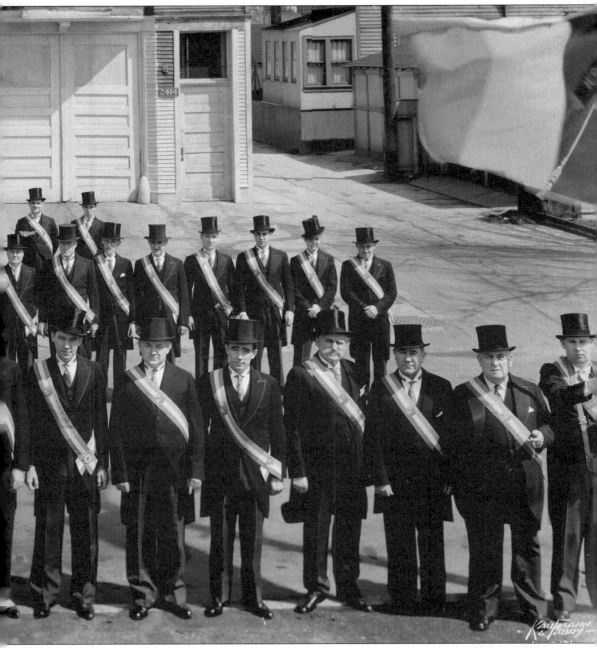

congregations, Queen of Angels accommodated both ethnic groups from its founding in 1909. (Photo courtesy of Joe McGovern/AOH.)

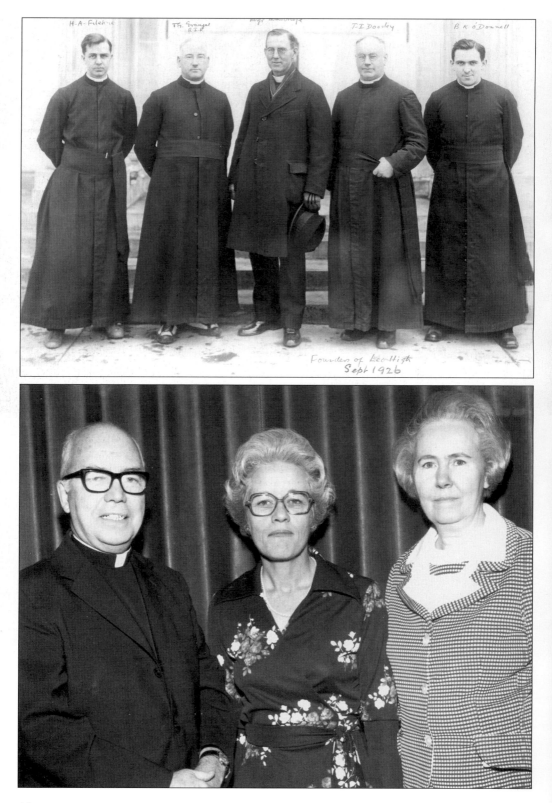

H·A·Filehne T.S. Granger R.I.P Mgr Mallcourt T.I. Doorley B.K. O'Donnell

Founders of Leo High
Sept 1926

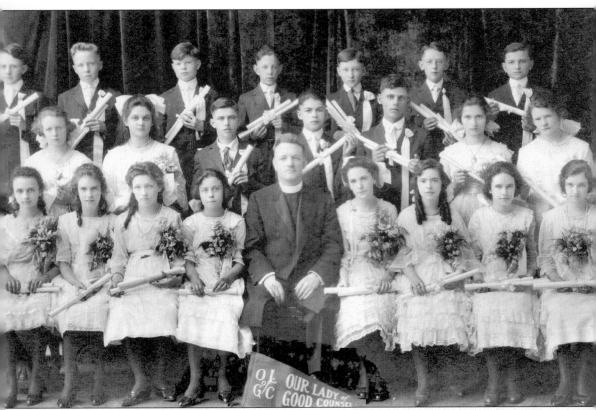

Rev. Thomas Small poses with the 1919 graduating class of Our Lady of Good Counsel at 35th and Hermitage. A fervent Irish nationalist, Small incorporated Irish history into the school curriculum. The majority of the students pictured here hold two diplomas, one for grammar school graduation and the other from the Ancient Order of Hibernians for Irish history studies. (Photo courtesy of Our Lady of Good Counsel Parish.)

Opposite, Top: In the 1920s, the Christian Brothers of Ireland established a presence in Chicago with the opening of Leo High School at 79th and Peoria. The bustling 79th Street area was settled in the early part of the century, largely by Irish Catholics migrating south from older parishes. For Rev. Peter Shewbridge, pastor of St. Leo the Great parish, opening a high school for boys in the neighborhood was a priority. Pictured from left to right are Brother H.A. Filehne, Brother T.G. Grangel, Reverend Shewbridge, Brother T.I. Doorley, and Brother B.K. O'Donnell. (Photo courtesy of the Congregation of Christian Brothers.)

Opposite, Bottom: Msgr. Jack Egan, Peggy Roach, and Sister Ann Ida Gannon, BVM, are three Chicagoans who have brought honor to the Irish community. Roach and the late Monsignor Egan led lives of Christian activism, fighting for social justice and equality in Chicago and nationwide, participating in historic civil rights events like the 1965 March at Selma with Dr. Martin Luther King Jr. Gannon is the former president of Mundelein College (1957–1975) and for decades has played an active role in women's rights advocacy both nationally and locally. (Photo courtesy of Women and Leadership Archives of the Ann Ida Gannon, BVM, Center for Women and Leadership, Loyola University Chicago.)

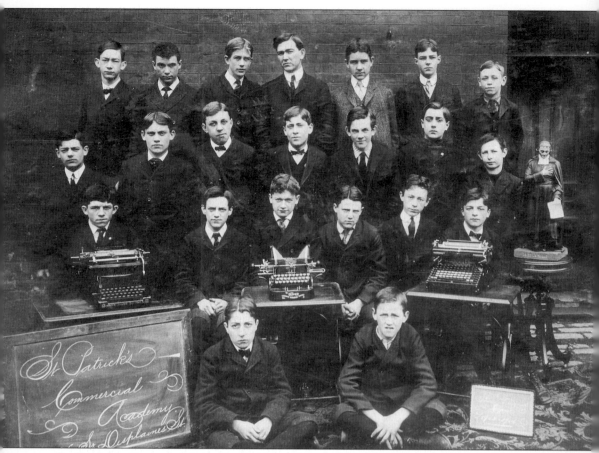

St. Patrick's Commercial Academy prepared boys with the skills necessary to occupy clerical positions in the city's ever-growing commercial sector. This 1903 class is posed with state-of-the-art tools of the trade, along with a statue of St. John Baptist De LaSalle, the founder of the Brothers of the Christian Schools, the order that established the academy. (Photo courtesy of St. Patrick High School.)

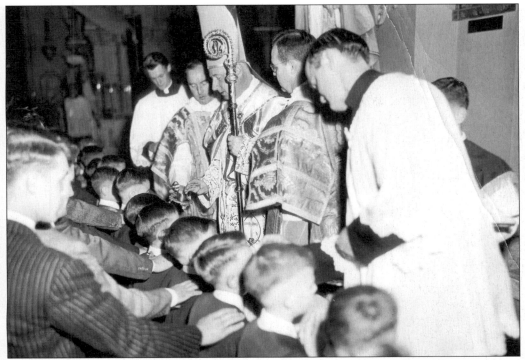

With their sponsors laying the right hand on the right shoulder, as tradition dictates, young parishioners at St. Gabriel church are confirmed by Archbishop William Cousins in 1949. The sacrament was preceded by a well-attended evening procession that led to the church, with the marchers flanked on both sides by family members and neighbors. (Photo courtesy of St. Gabriel Parish.)

In this 1984 photo, Irish Christian Brothers J.B. Sloan, P.R. Kiely, and G.A. Kealy relax and enjoy a well-deserved retirement at the Brother Rice monastery after decades of teaching South Side Catholic high school boys. (Photo courtesy of the Congregation of Christian Brothers.)

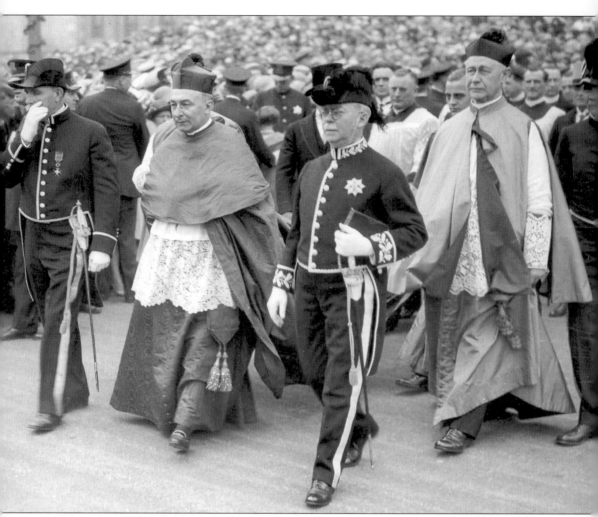

Lumberman Edward Hines (center, with Cardinal Mundelein to his right), dressed in the uniform of the Order of St. Gregory, attends the Eucharistic Congress of 1926 at Soldier Field. The son of Irish immigrants, Hines founded the Edward Hines Lumber Company in 1892 and eventually opened over two dozen retail outlets in the Chicago area. The successful businessman also believed in giving back to his community. Hines donated the land and underwrote the construction of the Edward Hines Jr. Veterans Hospital in 1920, and provided the funds to build the Chapel of the Immaculate Conception at St. Mary of the Lake Seminary in Mundelein. (Photo courtesy of Edward Hines Lumber Co.)

Four
MUSIC AND DANCE

Irish music and dance are the most public expressions of Irish culture in Chicago. With dance schools enrolling thousands of students and live music available in venues around the city every night of the week, the Irish maintain a much higher cultural profile than any of the other European ethnic groups. It might also be argued that a high level of participation in these and other arts will keep the Irish community in Chicago dynamic rather than nostalgic in an era of greatly reduced immigration.

Music has always been an important aspect of the Irish experience in Chicago. When Francis O'Neill set out to collect the tunes he heard being played around the city at the turn of the last century, he found musicians in nearly every neighborhood. The liveliness of the scene depended in part on the ebb and flow of immigration. At the end of his life, O'Neill despaired of the lack of newcomers to replace an aging music community, unable to forsee the renewed immigration at the end of World War II that would enrich traditional music circles. From the 1940s through the 1960s, Irish Chicagoans enjoyed a lively music and dance scene that revolved around dance halls on the North, South, and West Sides of the city, places like McEnery Hall on Madison and Pulaski and Hanley's House of Happiness on 79th Street.

Chicago's Irish dance community has benefited from the dedication of teachers like Mae Kennedy Kane and Pat Roche, whose years of instruction insured the passing on of the dance tradition to later generations. The institution of yearly *feisanna* and *fleadhanna cheoil* (festivals of dance and music) also helped to create a focus and spirit of competition among dancers and musicians in Chicago.

Currently, the most talented of Chicago's Irish musicians and dancers enjoy an unprecedented popularity and artistic freedom, exploring the tradition and taking it in new directions. While artists such as John Williams, Mark Howard, and Liz Carroll continue to produce fine work, teachers like Sheila Ryan of the Trinity Academy of Irish Dance and Noel Rice of the Academy of Irish Music train the artists of tomorrow.

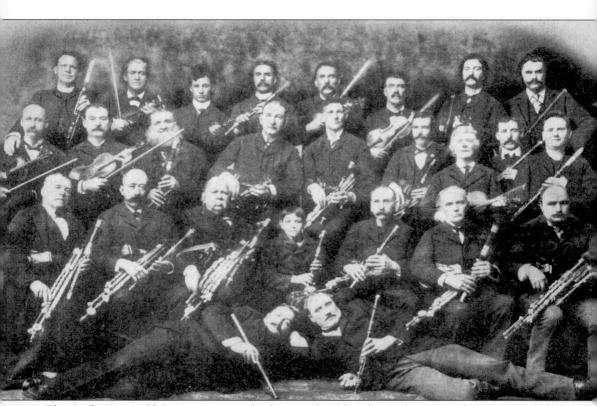

The Irish Music Club was composed of men who played together around the turn of the century. Participants came from neighborhoods like Brighton Park, which was known for its concentration of Irish musicians. The club's most noted member was Francis O'Neill, the chief of police who assiduously catalogued Irish melodies that had been passed on by memory over generations. O'Neill is top row, fourth from left, with his son Rogers to his right. (Photo courtesy of Kevin Henry.)

Other than appearances suggesting a musical competition, not much is known about the circumstances that prompted this photograph, taken in 1924, possibly at Gaelic Park at 47th and California. Musician Kevin Henry has identified the fiddler third from left as Theresa Geary. (Photo courtesy of Irish American Heritage Center.)

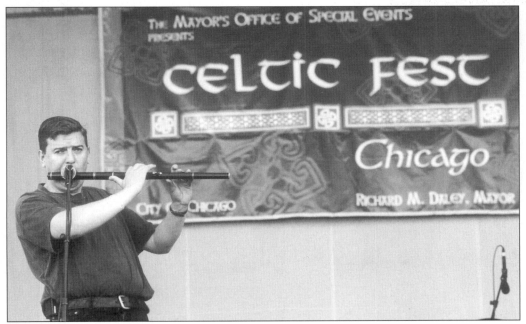

Recognizing the explosion of interest in Celtic arts and culture in recent years, the City of Chicago hosted the first Celtic Festival in Grant Park in fall 1997. The pan-Celtic celebration of music and art features the best of Chicago's traditional Irish musicians as well as talent from Celtic regions in Europe and North America. Above, Fermanagh-born Chicago resident Laurence Nugent entertains the crowd in 1999. (Photo courtesy of the City of Chicago/Mark Montgomery.)

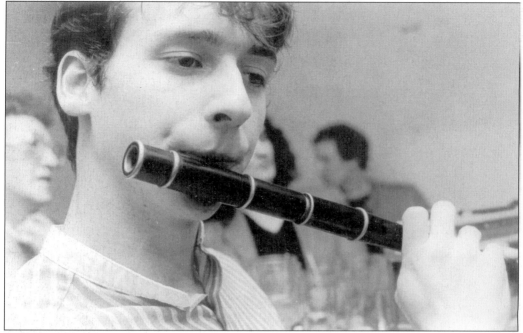

Today, John Williams is a renowned figure in the world of traditional Irish music, with dozens of recordings and compositions for the stage and film to his credit. As a teen, he could be found participating in sessions at the 6511 Club on South Kedzie. In this mid-1980s photo, the future All-Ireland senior concertina champion hones his skills on the flute. (Photo courtesy of James Healy.)

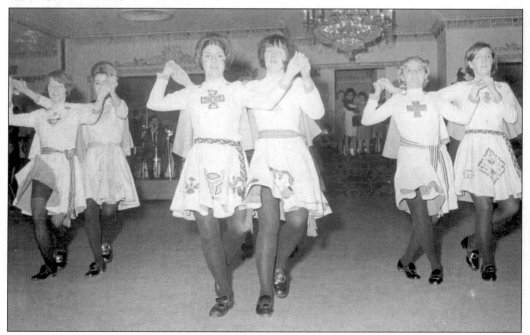

Before Curly Hair Wig #222 became a staple on the dance circuit, Irish dancers blasted their hair into submission with Aqua Net. The above photo shows Dennehy dancers performing at a 1968 function. (Photo courtesy of the Fahey family.)

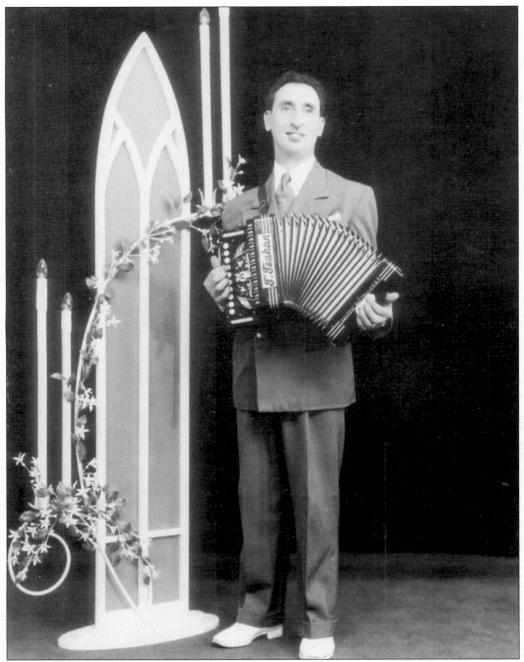

Accordion player Terence "Cuz" Teahan (shown here in a late-1940s portrait) kept a busy schedule playing at the numerous Irish dance venues around the city in the 1940s, 50s, and 60s. The engagements could be grueling, as he explained to writer Lawrence McCullough: taking the bus and streetcar from his West Side residence to a Saturday evening dance at 47th and Halsted, playing into the dawn hours, and arriving back home in just enough time to attend eight o'clock mass on Sunday morning. In addition to playing three nights a week, he worked full time with the Illinois Central railroad and raised three daughters with his wife, Nora. (Photo courtesy of the Teahan family.)

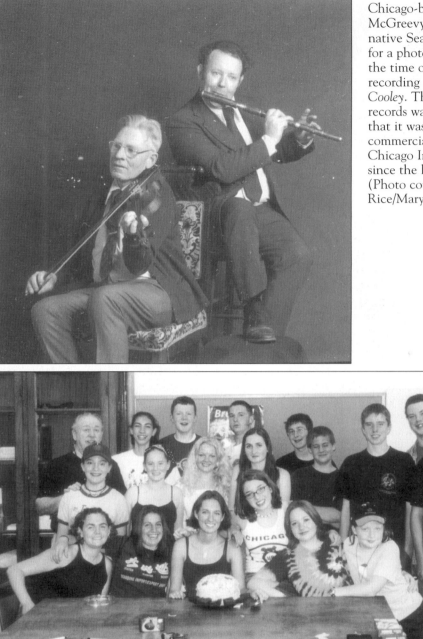

Chicago-born John McGreevy and Galway native Seamus Cooley sit for a photo session around the time of their 1974 recording *McGreevy and Cooley*. This LP for Philo records was a milestone in that it was the first commercial recording of Chicago Irish musicians since the late 1930s. (Photo courtesy of Noel Rice/Mary Cooley.)

Noel Rice (standing, left) and students from the Academy of Irish Music take a break from practice to celebrate a birthday. Rice, a native of County Offaly, has been teaching music in Chicago since his arrival in the early 1960s. His Wednesday and Saturday classes at the Irish American Heritage Center have a collegial, relaxed atmosphere. Rice explains that the classes aren't about youngsters learning to play Irish music for their parents' sake, but rather about building a community of musicians who will inspire each other and continue to play together into their adult lives.

The Clancy Brothers and Tommy Makem smile for Eileen O'Connor backstage during a May 1961 appearance at the Gate of Horn, a folk club at Chicago and Dearborn that was the era's "social center for the hip crowd." Just two months earlier, the Clancys and Makem had gained national recognition after an unprecedented 16-minute set on the Ed Sullivan variety show. (Photo courtesy of Irish American Heritage Center.)

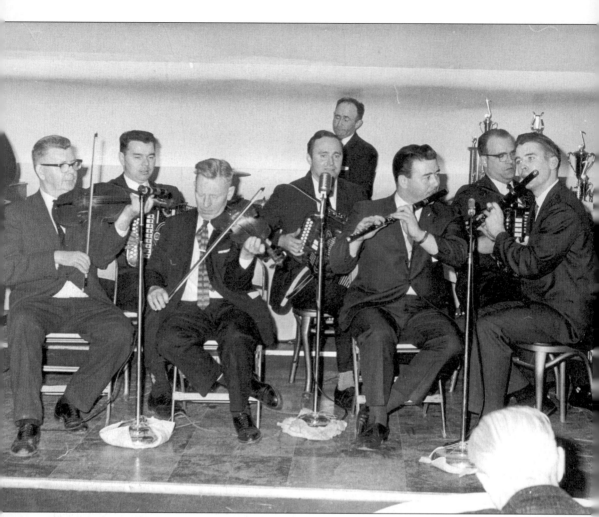

The winning ceili band takes the stage at the 1965 *Fleadh Cheoil* (feast of music) at the Keyman's Club on the West Side. Seated from left to right, are James Neary, Tim Clifford, John McGreevy, Pat Cloonan, Noel Rice, John Lavelle, and Jim Thornton. (Photo courtesy of Noel Rice/Charles Jarmull.)

Opposite: Over the course of the last century, few have had as profound an impact on Irish cultural life in Chicago as dancer Pat Roche. From his legendary assembling of young musical talent for the 1933–34 Century of Progress World's Fair, to his consistent promotion of and participation in festivals of Irish music and dance in Chicago, Roche has been instrumental in keeping traditional Irish art forms alive in the city. The Clare native taught dancing at schools around Chicago for 40 years, and many of his students have gone on to become teachers themselves. As Trinity Academy director Mark Howard explains, "There is not a dancer in Chicago who has not been influenced directly or indirectly by the work of Pat Roche." (Photo courtesy of Trinity Academy of Irish Dance.)

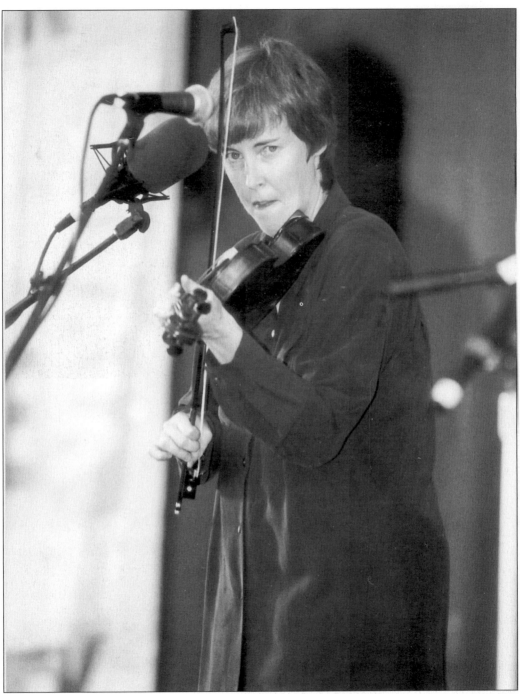

A musician and composer of international stature with deep cultural roots in Chicago—violin lessons with Sister Francine at Visitation Grammar School, musical evenings in 63rd Street Irish taverns in the 1970s—fiddler Liz Carroll enjoys the respect of peers and politicians alike. On the evening of the Celtic Festival performance pictured above, Carroll was honored with the news that Mayor Daley had proclaimed September 18, 1999 "Liz Carroll Day" in Chicago. (Photo courtesy of the City of Chicago/Mark Montgomery.)

Singer Eileen Kane, called "The Blarney Rose" after her signature song, was a featured performer on Maurice Lynch's Irish Hour on WCFL in the 1930s and 40s. Live performance, including dancing, was a regular part of radio in earlier years. (Photo courtesy of Tom Mescall.)

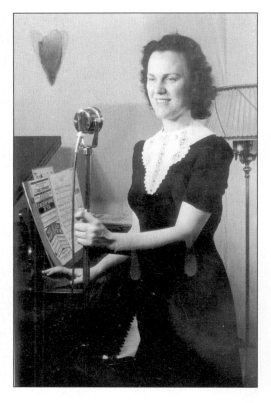

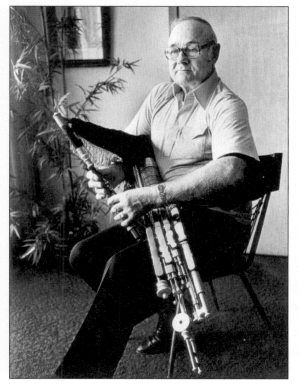

One of piper Joe Shannon's earliest engagements was a summer-long gig with the Harp and Shamrock Orchestra at the Irish Village in the 1933–34 World's Fair. In a meeting of generations that now seems symbolic, the teenager's piping was admired one day by visiting Chicago Irish music legend Chief Francis O'Neill, who presented Shannon with an autographed copy of his book *Irish Minstrels and Musicians*. In addition to his renowned piping skills, Shannon had a 28-year career with the Chicago Fire Department. (Photo courtesy of Maureen McGill/Noel Rice.)

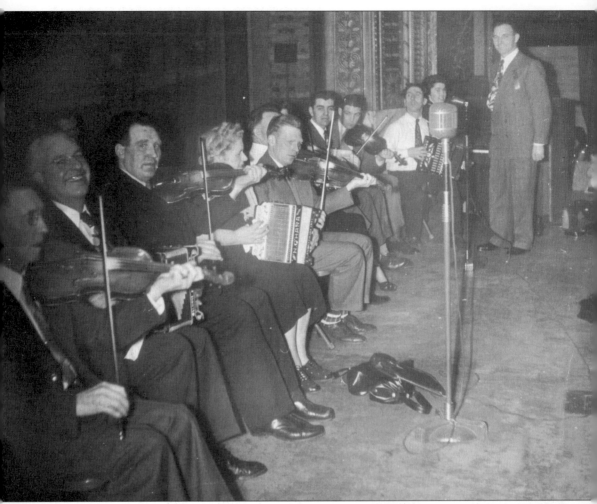

Benefits have always been a way for the Irish community to assist families burdened financially by illness or sudden death. In November of 1949, musicians gathered at Plumbers Hall to provide the entertainment at a benefit for the family of Chicago policeman Dave Keating, who was shot and killed in the line of duty. Pictured, from left to right, are the following: unidentified, Joe Shanley, Jim Donnelly, Mrs. O'Hara, John McGreevy, Tom Treacy, Tommy Sheehan, unidentified, Terence Teahan, Mazie Griffin, and Martin Fahey (standing). Fahey, the master of ceremonies for the event, has emceed the annual "Ireland on Parade" concert during St. Patrick's week since its beginnings at Ford City Shopping Center in 1968. The concert and week-long festivities are now held at Gaelic Park. (Photo courtesy of the Fahey family.)

Long before he became an international megastar with his own castle in County Cork, dancer Michael Flatley led a relatively quiet life on the Southwest Side, studying flute with Frank Thornton, dancing with the Dennehy school, and attending sessions around town with contemporaries Liz Carroll and Marty Fahey. At right, Flatley as a freshman at Brother Rice High School in 1974, sports a little more hair over the ears than dean of students Brother McGraw normally allowed in those days.

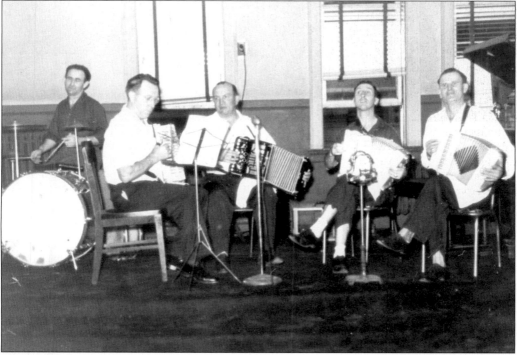

Pictured above, members of Tom Treacy's band play an engagement at McEnery Hall (Madison and Pulaski) in the 1950s. Pictured, from left to right, are John Cooke, Tom Treacy, Tim Guiheen, Terence Teahan, and Tom Kerrigan. (Photo courtesy of the Teahan Family.)

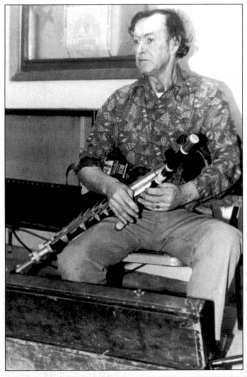

Flute player and piper Kevin Henry is one of Chicago's most respected traditional musicians, especially revered by younger players whose talents he has nurtured and encouraged over the years. He is also a storyteller and an actor and has kept the tradition of tavern sessions alive for decades. Every year on Memorial Day he can be found playing his flute at the tomb of legendary Irish music collector Francis O'Neill in Mount Olivet cemetery. (Photo courtesy of James Healy.)

This photo of the 1958 Pilsen Park *Feis* features contestants in a dance competition. (Photo courtesy Archdiocese of Chicago's Joseph Cardinal Bernadin Archives and Records Center.)

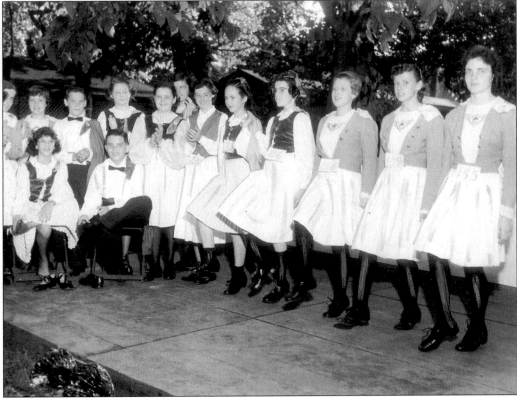

This portrait of "Sligo Jack" Finan by James Healy would be instantly recognizable to anyone who spent time at the 6511 Club on South Kedzie. A barman without peer, the charismatic Finan was a musician and an ambassador of traditional and contemporary Irish culture, as at home with Yeats as he was with Horselips. To have enjoyed his energetic company on a quiet weekday night at the bar was undoubtedly the high point of many a South Sider's tavern life. (Photo courtesy of James Healy.)

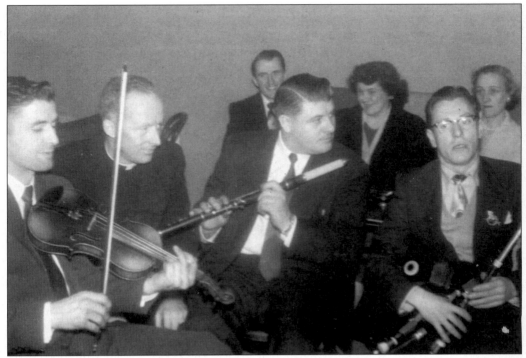

Rev. Gerry Smith listens intently as fiddler Jack Fitzgerald, flute player Tom Masterson, and piper Sean McGuire play a tune at McDermott's, 55th and Ashland. The occasion was a 1955 benefit for the Columban Fathers, an Irish missionary order. (Photo Courtesy of Irish American Heritage Center.)

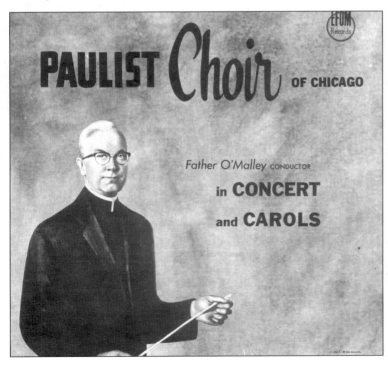

Directed by Rev. Eugene O'Malley from 1928 until his retirement in 1967, Chicago's Paulist Choir was known the world over for its excellence and purity of sound. Father O'Malley was said to be the inspiration for the Bing Crosby character in the 1940s box office hits *Going My Way* and *The Bells of St. Mary's*. This 1967 album marks the choir's final recording.

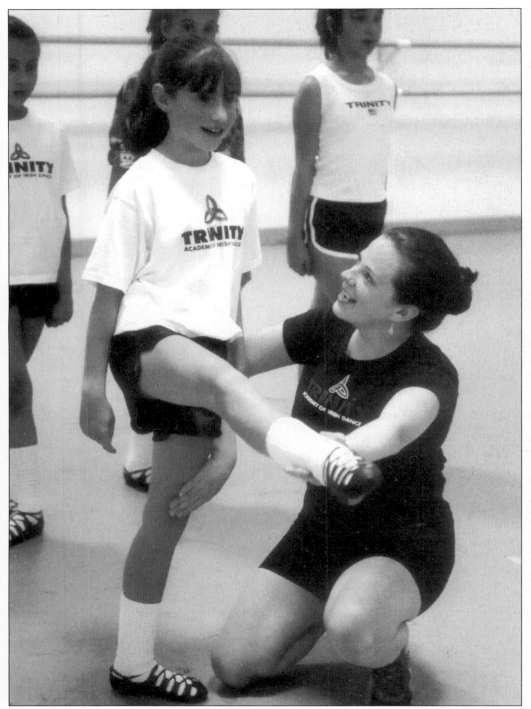

Young dance instructors like Sheila Ryan of the Trinity Academy of Irish Dance are assuring the continued vigor of the art form well into this century. A dancer with Trinity since the age of ten, Ryan has won every award imaginable, including gold medals at Worlds for both dancing and coaching. In the photo above, she helps student Killian Hlava with her technique. (Photo courtesy of the Trinity Academy of Irish Dance.)

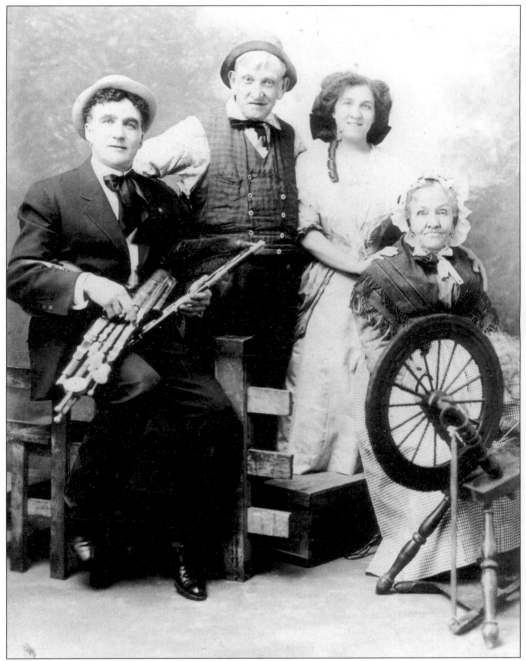

Despite its resemblance to a publicity still for any current Martin McDonagh play, the above photo was taken around 1910. Charlie Mack (McNurney) and Edna, the younger two of the quartet, were Chicago-based vaudevillians whose particular stock of song, dance, and humor would have struck a chord with Irish and Irish-American audiences of their day. Edna was actually of English-Jewish origin, while Charlie's proficiency on the pipes extended only as far as the ten tunes he learned for their stage show. (Photo courtesy of the McNurney family.)

Five

THE MAYORS

Chicagoans of a certain age might be excused for assuming that, with a few recent exceptions, the mayor of the city has always been of Irish descent. In fact, there were 28 mayors, many of them Republican, preceding Chicago's first Irish Catholic mayor, John Patrick Hopkins, who was elected in 1893. Even after Hopkins, a few more Republican and non-Irish mayors were to follow before the long Irish tenure in the office began with Mayor Kelly in 1933.

In his essay "Political and Nationalist Dimensions" from *The Irish in Chicago*, Michael Funchion points out the reasons why the Irish fell into politics naturally. They were native English speakers, familiar with English-derived politics, and had old-country experience at getting around the inequities of British rule—skills that served them well in the freewheeling style of politics that developed in Chicago. From the 1860s to the turn of the century, the Irish held about one third of the aldermanic seats, a percentage far greater than their numbers in the city. Saloonkeeper bosses with colorful names like "Bathhouse John" Coughlin, Michael "Hinky Dink" Kenna, "Foxy Ed" Cullerton, and Johnny Powers operated in the same sphere of government as more reputable Irish politicians like John Comiskey (father of Charles), Republican furniture retailer John M. Smyth, and Judge Edward F. Dunne, who was to become the city's second Irish Catholic mayor.

The Irish might have dominated the top positions in city government earlier but for factionalism among the Democrats, a viable Republican party, and a considerable block of reform-minded voters. In 1923, another Irish Catholic, William E. Dever, occupied the mayor's office for one term, but it took Mayor Anton Cermak to unify the Democratic party and pave the way for a succession of Irishmen in city hall: Mayors Edward J. Kelly, Martin H. Kennelly, and Richard J. Daley.

While Irish control over the mayor's office and top Democratic positions may have seemed a divine right at mid-century, the same demographic changes that allowed the Irish to supplant the native Anglo-Protestants have in turn transformed contemporary Chicago into a diverse mix of races and nationalities. However modern, mayors like Jane Byrne and Richard M. Daley certainly owe a great deal of their success to an earlier tradition of Irish politics. Future mayors of Irish descent will most likely chart an entirely new course appropriate for 21st century Chicago.

A suburban retailer who was instrumental in Chicago's annexation of Hyde Park, Lake View, Jefferson, and the town of Lake in 1889, John P. Hopkins was Chicago's first elected Irish-Catholic mayor. He was nominated after the shooting death of Mayor Carter Harrison Senior, and served from 1893 to 1895 (mayoral terms then were two years). (Photo courtesy of Chicago Historical Society, ICHi-21935.)

Dublin-educated Edward F. Dunne is the only Irish Catholic to have held the offices of Mayor of Chicago and Governor of Illinois. The intellectual and urban populist (both Jane Addams and Clarence Darrow played roles in his administration) had a brief reign as mayor, from 1905 to 1907, but was elected governor in 1912. Dunne was also a staunch supporter of Irish causes: he traveled to the Paris Peace Conference in 1919 to lobby for Irish independence, and he helped promote Eamon De Valera's bond-certificate sales campaign in the U.S. (Photo courtesy of Special Collections and Preservation Division, Chicago Public Library.)

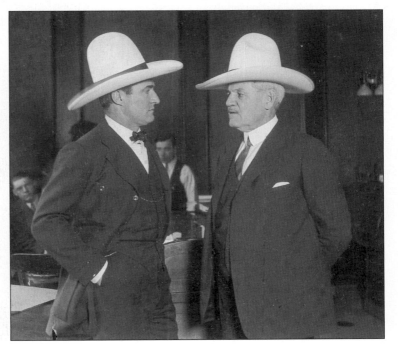

$10 SECOND EXTERNAL LOAN $10

REPUBLIC OF IRELAND

* BOND CERTIFICATE *

TEN DOLLARS

13693 13693

To * * * * * * * JAMES STACK * * * * * *

I Eamon De Valera, President of the Elected Government of the Republic of Ireland, acting in the name of and by the authority of the elected representatives of the Irish Nation, issue this Certificate in acknowledgment of your subscription of Ten Dollars to the Second National Loan of the Republic of Ireland. This Certificate is not negotiable but is exchangeable if presented at the Treasury of the Republic of Ireland one month after the international recognition of the said Republic, for one Ten Dollar Gold Bond of the Republic of Ireland. Said Bond to bear interest at five per cent per annum from the first day of the seventh month after the freeing of the territory of the Republic of Ireland from Britain's military control and said Bond to be redeemable at par within one year thereafter.

DATED NOVEMBER 15TH 1921 APPROVED BY DAIL EIREANN AUGUST 26TH 1921

Seán na Dúnaín Eamon De Bailéara
REGISTRAR PRESIDENT

Six months after Sinn Fein was elected to power in 1918 and its leaders declared an Irish republic, Dáil Eireann President Eamon De Valera began an extended tour of the United States. His mission was twofold: to gain American support for his new government, and to raise money for its operations. The $10 bond certificate above, issued in Chicago, bore a promise of five percent interest "from the first day of the seventh month after the freeing of the territory of the Republic of Ireland from Britain's military control." Former Chicago mayor and Illinois governor Edward Dunne assisted De Valera with the bond campaign, which netted the fledgling Irish government over five million dollars. (Courtesy of Maureen O'Shea.)

Mayor William E. Dever, the son of Irish immigrants, poses with cowboy star Tom Mix. The white hat was appropriate for Dever, elected as a reformer in 1923 to rein in the Chicago of the Roaring Twenties. Dever's efforts to rid the city of the excesses spawned by Prohibition cost him a second term. (Daily News photo courtesy of Chicago Historical Society, DN-0078892.)

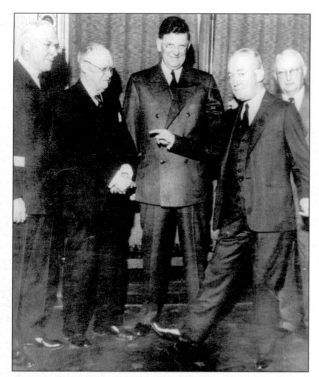

The first of Chicago's Irish mayors to serve more than one term, Edward J. Kelly was initially elected by the City Council in 1933 to complete the term of assassinated mayor Anton Cermak. He would go on to win three more elections, serving as mayor throughout the World War II years. In this photo, Broadway musical legend George M. Cohan demonstrates a step to Kelly (center) and others. (Photo courtesy of Dan McLaughlin.)

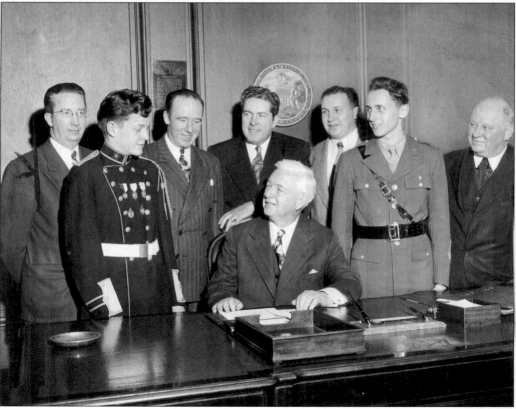

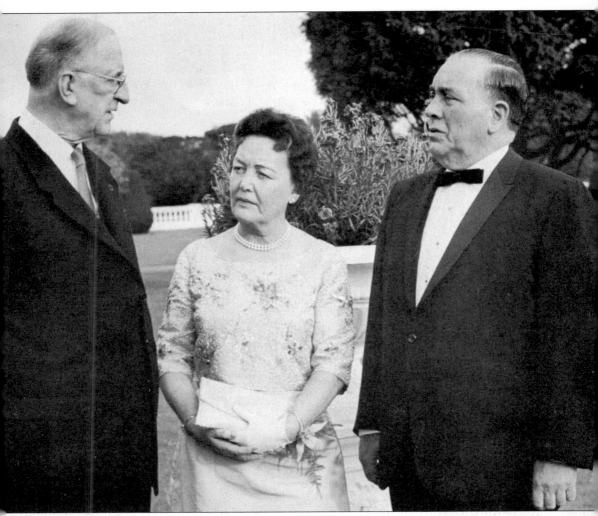

The subject of more than a dozen books, and probably the only Chicago mayor whose portrait has held a place of honor above the bar in countless taverns, Richard J. Daley has come to symbolize a bygone era of neighborhood-based big city politics. A man who lived in the same parish his entire life, yet governed the city at a time when it was flexing its economic muscle by building the largest skyscraper in the world, Daley was a complex leader whose tenure as mayor will be a subject of interest to historians for years to come. In this photograph, Daley and his wife, Eleanor, share a moment with Irish President Eamon De Valera during a 1964 visit that included a stop at the Mayor's ancestral home, Dungarven, Waterford. (Photo courtesy of the St. Patrick's Day Parade Committee.)

Opposite: Martin J. Kennelly succeeded Edward Kelly in the Mayor's office. Kennelly served two terms, from 1947 to 1955, but his enthusiasm for reform and replacing patronage jobs with civil service positions cost him a third endorsement from the Democratic Party leadership. In this photograph, Kennelly marks the centenary of the Christian Brothers in Chicago by declaring May 2, 1948 Christian Brothers Day. Surrounding Kelly, from left to right, are present or former students: William McKenna, Francis Moran, Ald. Nicholas Bohling, Ald. John E. Egan, Ald. Edmund J. Hughes, Carl LeVander, and Brother Hugh, F.S.C. (Photo courtesy Archdiocese of Chicago's Joseph Cardinal Bernadin Archives and Records Center.)

Besides its historic significance as the contest that elected Chicago's first woman mayor, Jane Byrne's 1979 victory signaled the beginning of a transitional era in the city. As mayor, she began to address quality-of-life issues that helped Chicago evolve from its moribund "hog butcher for the world" past into a model for contemporary urban life. In this photo she is accompanied by Irish Taoiseach Jack Lynch during his 1979 visit to Chicago. (Photo courtesy of Jane M. Byrne.)

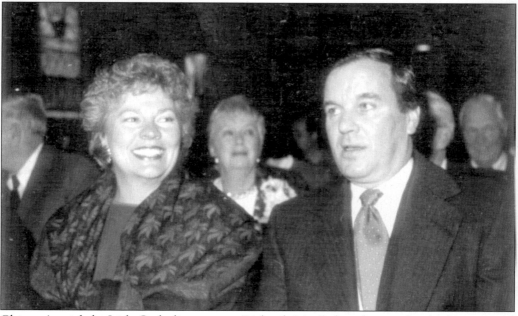

Chicago's eighth Irish-Catholic mayor, Richard M. Daley, has a family history and neighborhood background that make him a natural for the mayor's office—credentials that only begin to explain the popularity of a leader who has held the office longer than any mayor except his father. His responsiveness to Chicago's diverse communities and the appreciable improvements in neighborhoods citywide have won him high marks from all quarters. In this photo, Daley and his wife, Maggie, attend the St. Patrick's Day Parade mass at Old St. Patrick's Church. (Photo courtesy of the St. Patrick's Day Parade Committee.)

Six

OCCUPATIONS
AND PROFESSIONS

It has been said that the Irish work experience in Chicago—or any American urban center where the Irish settled—can be summed up by a trio of professions that begin with the letter *p*: politics, the police, and the priesthood. Chicago's Irish began entering politics shortly after they established themselves in the city, becoming a dominant force as the population grew and matured in the late 19th century. They were also the predominant ethnic group in the Chicago Police Department. Lastly, the network of Irish parishes that were founded across the city quickly produced vocations, not only to the priesthood, but to women's religious orders and the brotherhood as well, which increased Irish representation in the Chicago Church.

The "proletarian pioneers of the ghetto"—historian Lawrence McCaffrey's term for the Famine-era Irish immigrants—worked jobs suited to unskilled newcomers. They dug canals and building foundations, carried bricks and mortar, and built the railroads that originated in the city. It would only be a matter of time, however, until they progressed to supervisory positions in such work crews, and learned the trades that they would later come to represent as union leaders. The Irish also filled municipal jobs with the fire department, transit companies, and City agencies connected to the growing patronage workforce. Irish-American women who had been educated in parochial schools emerged as teachers and leaders in the Chicago public school system, an institution that formerly had been hostile to Irish-Catholic participation and anti-Catholic in its curriculum.

As the Irish broke down the remaining opportunity barriers and continued their inevitable march into the middle class, they reaped the benefits of a Catholic educational infrastructure that had been built over decades and encompassed learning from the earliest grades to university studies. While they still favored jobs with the police force and city government, Chicagoans of Irish descent took their place in every profession, as likely to be lawyers, doctors, and commodities traders as they were bricklayers, tavern owners, and firemen.

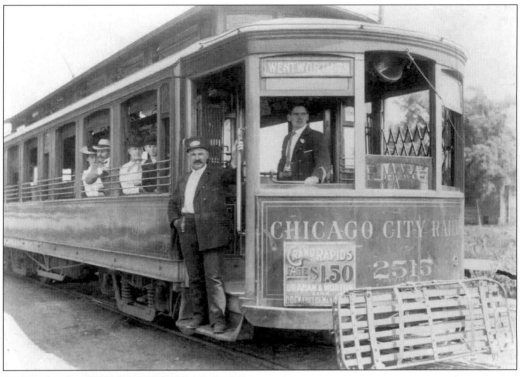

Young streetcar operator Peter Foote (right) works the Wentworth route in 1905, a time when cowcatchers on the front of the vehicles were still necessary to nudge the occasional farm animals and other obstacles out of the way. A first-generation American born to Irish parents, Foote went on to develop real estate on the Southeast Side. (Photo courtesy of Peter Foote.)

Looking dapper in his mourning suit, funeral director Thomas J. Cooney attends to a procession outside St. Andrew church around 1940. The Cooney family has been burying the North Side Irish from their Addison and Southport location since the early 1920s, prompting the slogan: "You don't go to heaven unless you go to Cooney's." (Photo courtesy of the Cooney family.)

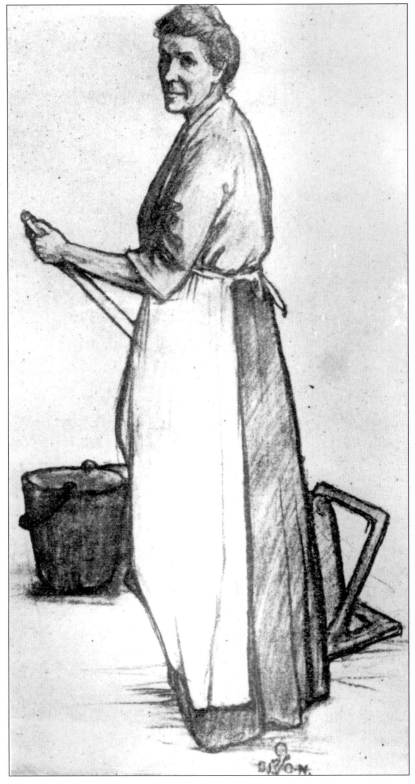

Entitled "Mrs. Sweeney, the Scrub Woman," this drawing accompanied a 1904 essay about the Hull-House Labor Museum, a place where visitors could watch area immigrants practice crafts from their countries of origin. Mrs. Sweeney, employed to clean the museum, accompanied the writer on part of her visit. Her comments were transcribed as spoken, in a broad Irish dialect. (Photo courtesy of Jane Addams Memorial Collection, The University Library, University of Illinois at Chicago.)

Pictured here are two photographs of Stephen Fitzgerald, the first taken around 1905 when he was a cadet in the fire department, the second taken years later after he was retired and working as watchman at the Goldblatts department store at Chicago and Ashland. Fitzgerald made a lateral career move early on, when he jumped from the fire department to the police force. He remained a police officer for 25 years. (Photo courtesy of Jim Kane.)

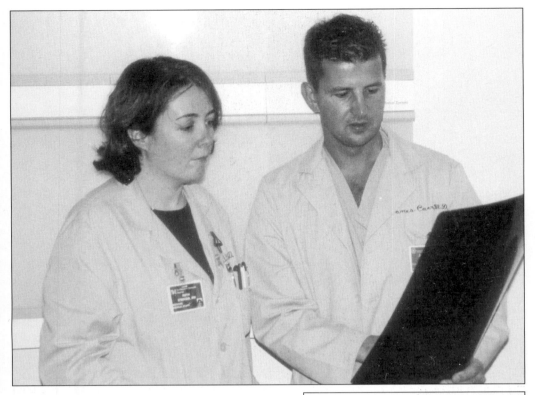

While the economic boom of the 1990s has virtually eliminated the need for Ireland's young to go abroad in search of work, Chicago continues to attract highly educated Irish professionals like Ruth O'Regan, M.D. and James Carr, M.D., physicians at Northwestern Memorial Hospital.

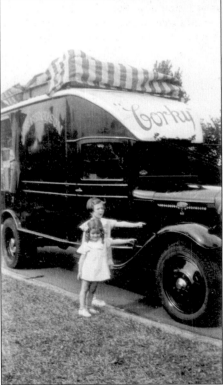

Corky's Traveling Midget Mart was a common sight on the South Side during the Depression. Plying his trade in an area roughly bounded by Vincennes and Cottage Grove between 67th and 87th Streets, George Ferguson sold everything from canned goods to toiletries to fresh produce from his truck, affectionately named "Corky." In this 1936 photo, daughter Alice and niece Noni Stokes pose in front of the traveling store. (Photo courtesy of George Ferguson.)

The son of a County Cavan-born Chicago alderman, Charles Comiskey chose a career as a baseball player in his teen years, and by 1895 he was a player, manager, and owner of a Western League franchise, which he moved to Chicago and renamed the White Stockings in 1900. The ballpark that bore his name was built in 1910, and the current stadium on 35th Street is still known as Comiskey Park. "The Old Roman," as Comiskey was called, gave up active control of the team after the 1919 Black Sox scandal, but the franchise remained in the family for decades. (Photo courtesy of Patricia Bellock.)

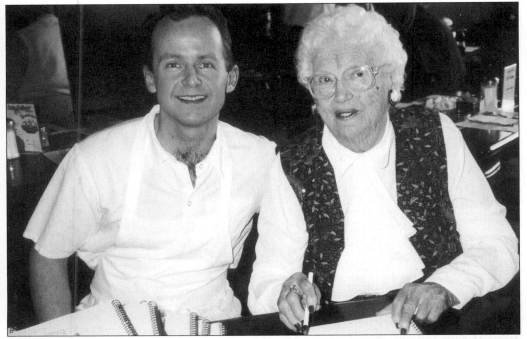

Restaurateurs Tom Tunney and Ann Sather pose at a cookbook signing. After buying Sather's popular Lakeview restaurant in 1981, Tunney, a graduate of St. Thomas More and Brother Rice, went on to open four more Ann Sather's locations downtown and on the North Side. Besides overseeing operations of the restaurants, Tunney has lent his support to countless community organizations and events. His hands-on commitment to neighborhood affairs has made Ann Sather's a model for socially responsible business practices. (Photo courtesy of Tom Tunney.)

The daughter of Irish immigrants, Chicagoan Dr. Alice Bourke Hayes has had a distinguished academic career spanning more than four decades. She spent over 20 years at Loyola University, first as a professor of natural sciences and later as an administrator, before leaving Chicago in 1989 to become the executive vice president and provost at St. Louis University. Currently, Dr. Hayes is the president of the University of San Diego. At left, Hayes (right) is pictured with fellow classmates at Mundelein College in the late 1950s. (Photo courtesy of Women and Leadership Archives of the Ann Ida Gannon, BVM, Center for Women and Leadership, Loyola University Chicago.)

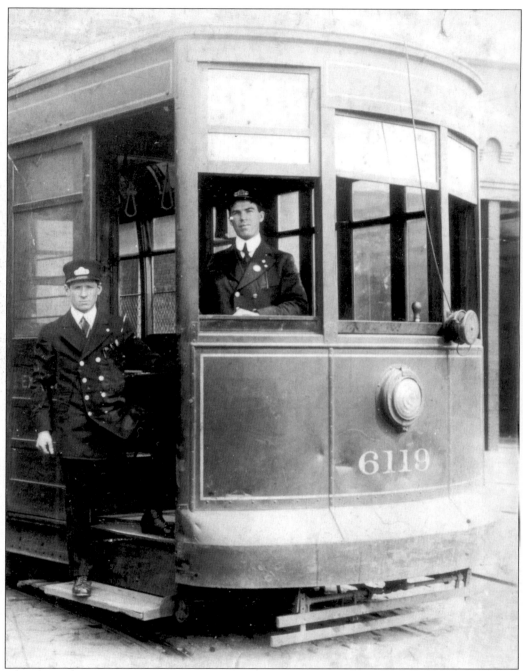

"He was so proud of his uniform," remembers Kathleen Hughes Gaughan of her father Thomas Hughes (above right), a native of Kilkerrin, Galway. "After all these years I still remember his badge number: 6307." Hughes immigrated in 1910 and was a motorman on the State Street streetcar at the time of this photo. After 40 years of service, Hughes retired from the Chicago Transit Authority (CTA) in 1958. (Photo courtesy of Kathleen Gaughan.)

Called "the storybook gangster of the 1920s" by crime author Jay Robert Nash, Dion O'Banion was the altar boy gone bad who controlled beer and whiskey distribution on the North Side during Prohibition. Responsible for at least 25 gangland murders, O'Banion himself was shot dead in his flower shop opposite Holy Name Cathedral in 1924. Cardinal Mundelein refused to allow the gangster's body to be buried in consecrated ground. (Photo courtesy of Jay Robert Nash.)

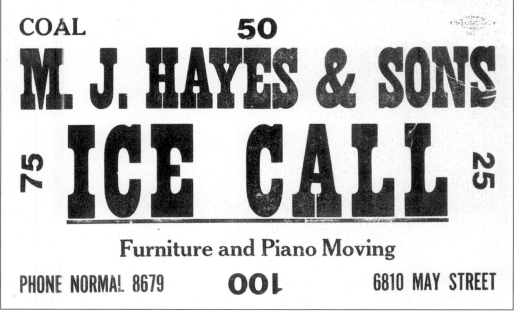

Hayes & Sons Storage and Moving started as a horse and wagon operation in 1915, when Limerick-native Michael Hayes began an ice and coal delivery service on the South Side. Customers for Hayes's ice service placed the ice call card on end depending on whether they wanted a 25-, 50-, 75-, or 100-pound block of ice. (Photo courtesy of Hayes & Sons Storage and Moving.)

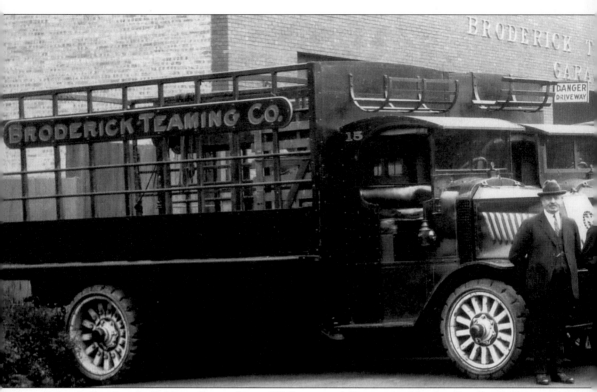

John J. Broderick (left) and sons Tom, William, and Dan assemble the Broderick Teaming Company truck fleet and crew for a late-1920s portrait. The senior Broderick, an immigrant from Limerick, founded the company in the 1890s with a wagon and three horses. Still located

Dr. Ann Lally is an excellent representative of a century-long tradition of Irish-Catholic women educators in the Chicago public schools. After graduation from Mundelein College in 1935, she taught art and English at a series of Chicago high schools and was eventually named director of art for the entire school system. She went on to study for her PhD at Northwestern University and became first a principal (at John Marshall High School) and then a district superintendent of schools in 1963, creating innovative new programs in each of her posts. (Photo courtesy of Women and Leadership Archives of the Ann Ida Gannon, BVM, Center for Women and Leadership, Loyola University Chicago.)

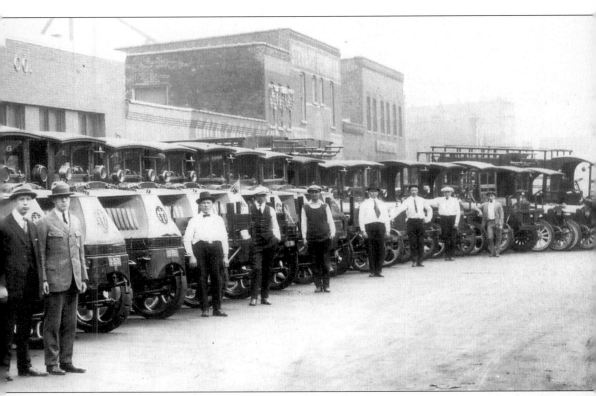

on Shields Avenue down the street from Comiskey Park, the company is now in its fourth generation of family ownership. (Photo courtesy of Broderick Teaming Company.)

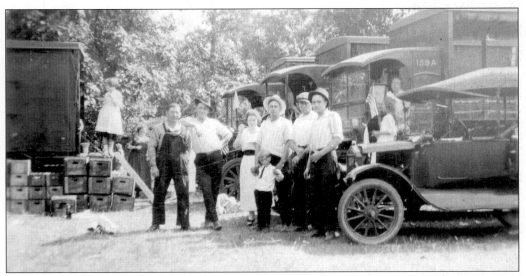

Employees of the John M. Smyth furniture stores enjoy a company picnic in the early 1920s. Born shipboard during his parents' 1848 transatlantic crossing, Smyth began retailing furniture at 19 years of age. His business prospered in the aftermath of the Great Fire of 1871, when city residents began rebuilding their homes and replacing furnishings that were lost in the flames. Thanks to aggressive and catchy advertising campaigns over the years, the John M. Smyth name is still synonymous with furniture to many Chicago area residents. (Photo courtesy of Pat Slapinski.)

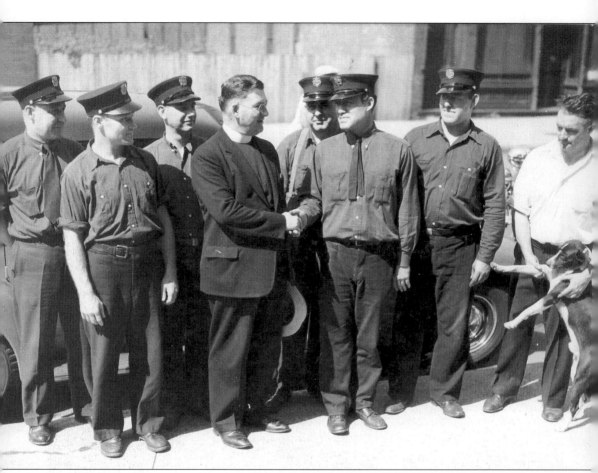

Msgr. William J. Gorman, Chicago's first fire department chaplain, greets the men of Engine Company Number 2 in 1938. (Photo courtesy of Archdiocese of Chicago's Joseph Cardinal Bernadin Archives and Records Center.)

Opposite, Top: The 1933 Century of Progress World's Fair was a boon for the heavily Irish electrical workers union, which was hit hard by the downturn in construction caused by the Depression. In this picture, electricians from Local 134 pose in a rail yard near the fair site, with the Tribune Tower rising majestically in the background. (Photo courtesy of I.B.E.W. Local 134.)

Opposite, Bottom: Orland Park mayor Dan McLaughlin greets Irish President Mary Robinson at a 1996 luncheon. Over the course of the 20th century, McLaughlin's family followed a common route of migration from the city's South Side Irish neighborhoods to the suburbs: moving from Bridgeport and Canaryville to 55th Street, then on to 79th Street, and then west to Oak Lawn and ultimately Orland Park. (Photo courtesy of Dan McLaughlin.)

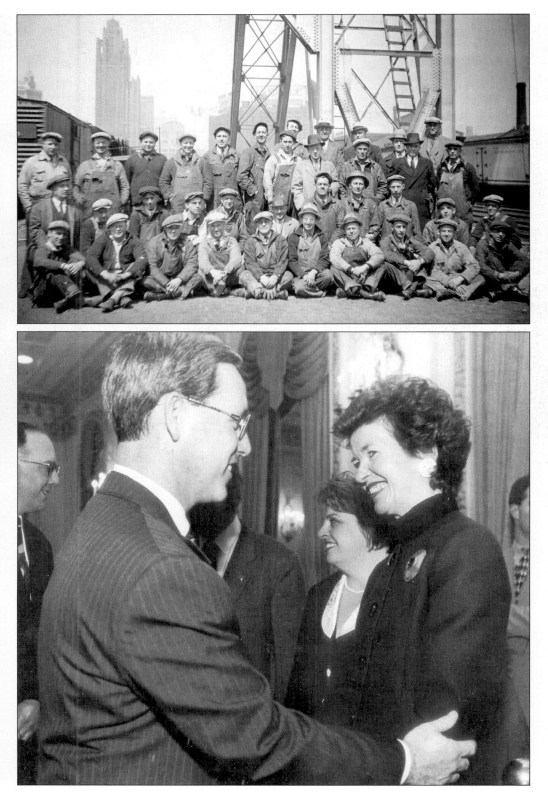

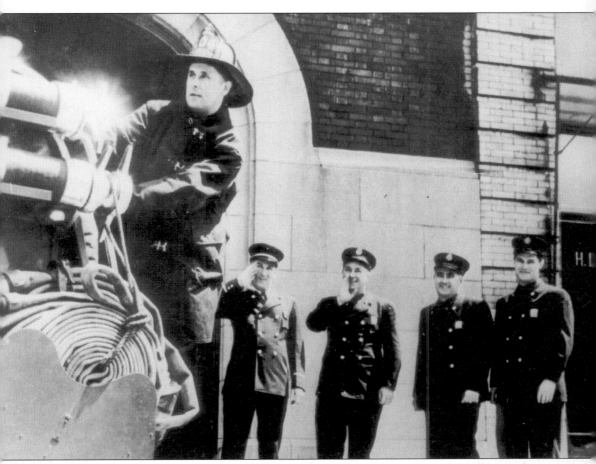

The firefighting Connors brothers—James, John, Pat, Thomas, and William—share a lighthearted moment at a firehouse at 14th and Michigan in 1957. Born and raised in Nativity of Our Lord Parish in Bridgeport, they were the sons of Cork natives John and Nora Connors (another brother, Francis, died in action in France in World War II; sister Mary was a housewife). All five brothers retired safely from the force, and four members of the next generation of Connors followed in the family tradition. (Photo courtesy of Fire Museum of Greater Chicago.)

Seven

ARTS AND CULTURE

In the 19th and 20th centuries, Chicago hosted several events of national stature that allowed Irish culture and arts to shine. The World's Columbian Exposition of 1893, held in Jackson Park, offered two popular Irish villages on its Midway. While certainly not the roiling Ireland of Douglas Hyde or James Joyce—both villages featured the rustic life of cottages and handicrafts—the exhibits were meant to promote the self-sufficiency of a future Irish state.

By the time of the Century of Progress World's Fair in Chicago in 1933–34, Ireland had its Free State and the Irish in Chicago had moved into the middle class in large numbers. The Irish Village at the Century of Progress was the product of Chicago artists and musicians whose talents are celebrated to this day. Chicago artist Thomas O'Shaughnessy designed a village that incorporated the aesthetics of the Celtic Revival, while the music and dance was provided by a stellar cast of young entertainers who would go on to become legends in the Irish music community.

O'Shaughnessy's artistry figured prominently in another major event showcasing Chicago. As president of the ecclesiastical art committee for the International Eucharistic Congress of 1926, he designed the poster and many of the decorations for the religious spectacle, held at different venues around Chicago, including Soldier Field. Soldier Field was also the setting for The Pageant of the Celt, a lavish 1934 production that extolled the glories of the ancient Celtic civilization.

The lives of the Irish in Chicago were explored by two authors of note, Finley Peter Dunne and James T. Farrell. In seven years of weekly newspaper columns, Dunne created a authentic portrait of the Bridgeport neighborhood and the Irish who lived there in the last years of the 19th century. James T. Farrell did the same for the Washington Park area of the South Side with a series of novels and short stories about the fictional Lonigan, O'Neill, and O'Flaherty families.

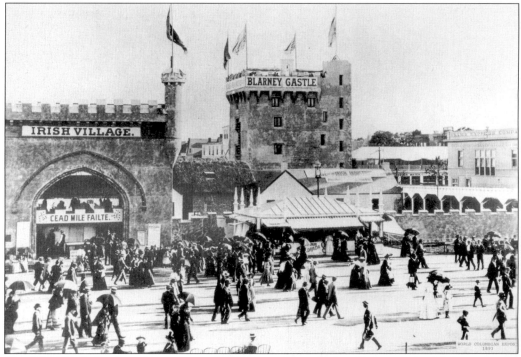

The World's Columbian Exposition of 1893 hosted two Irish villages on the Midway. In the village pictured above, fairgoers could explore a reproduction of Blarney Castle, view a replica of the Cormac Chapel at the Rock of Cashel, and observe "actual Irish" engaged in traditional handicrafts like lace making and weaving. (Photo courtesy of Dan McLaughlin.)

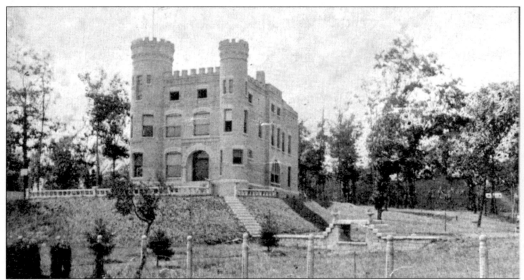

The Givens Castle at 103rd and Longwood Drive is a Beverly landmark. Built in 1886 by developer Robert Givens—possibly as a birthday present for his wife, or as a suitably romantic home to retire to and write novels—the castle was modeled after a similar structure Givens reportedly saw on a trip to Ireland. The photo above was taken around 1896, before additions altered the castle's design or other homes were built close by. (Photo courtesy of Ridge Historical Society.)

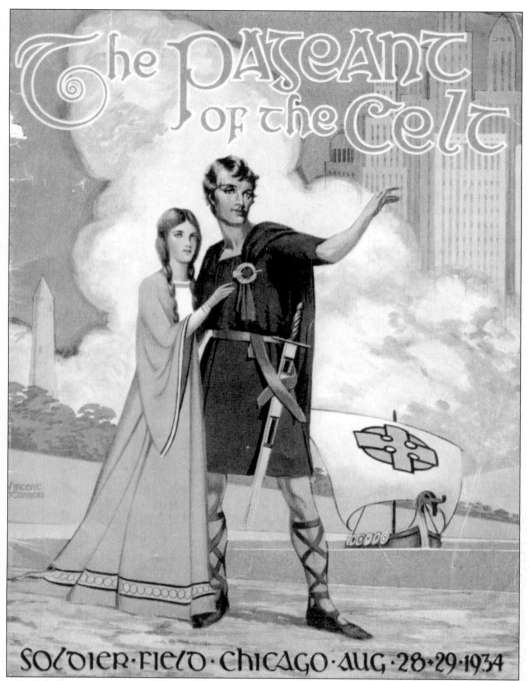

The PAGEANT of the Celt

SOLDIER·FIELD·CHICAGO·AUG·28·29·1934

The Pageant of the Celt was an ambitious music and dance extravaganza held at Soldier Field in August 1934. One thousand choristers and five hundred dancers were recruited locally for the production. The catalog for the pageant contained erudite discussions of Celtic arts by prominent Chicago university professors, and included a treatise on Irish music by former Chicago Police Chief Francis O'Neill. The cover illustration pictured above blends ancient and modern with renderings of a round tower and skyscrapers rising in the background. (Photo courtesy of Irish American Heritage Center.)

Looking like a set from the back lot at Warner Brothers, the Irish Village at the 1933 Century of Progress World's Fair was notable for its phenomenal music and dance lineup, which consisted of now-legendary Chicago talents like pianist Eleanor Kane Neary, dancer Pat Roche, and piper Joe Shannon.

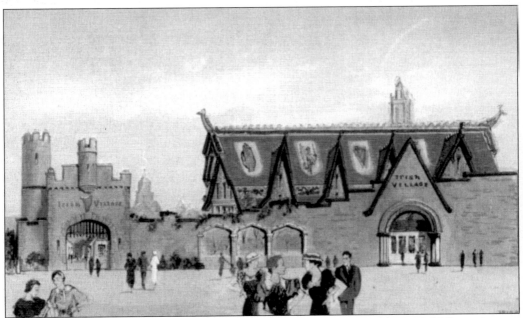

A postcard from the 1933 Century of Progress shows another view of the Irish Village. Artistic director Thomas A. O'Shaughnessy created the village's acclaimed Tara Hall, a half-timbered building decorated with Celtic tracery and the heraldry of the four provinces.

One of Chicago's fortunes is its ability to welcome artists who enrich the city with their gifts. The brilliant poet Michael Donaghy, who now resides in London, spent a few years in the city in the early 1980s while studying at the University of Chicago. A musician as well as a poet, he is shown here playing the bodhran at a 6511 Club session. (Photo courtesy of James Healy.)

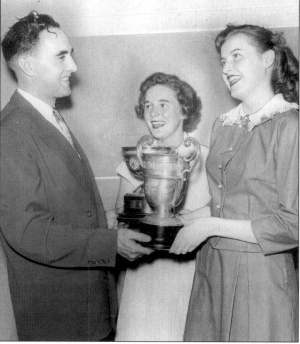

Organizer Pat Roche presents trophies to Cathleen Forrestal of St. Columbkille School and Maureen Buckley of Rosary College for their award-winning essays about the Irish Constitution. The occasion was the 1952 *Feis* (loosely translated as festival) at Pilsen Park. (Photo courtesy of Archdiocese of Chicago's Joseph Cardinal Bernadin Archives and Records Center.)

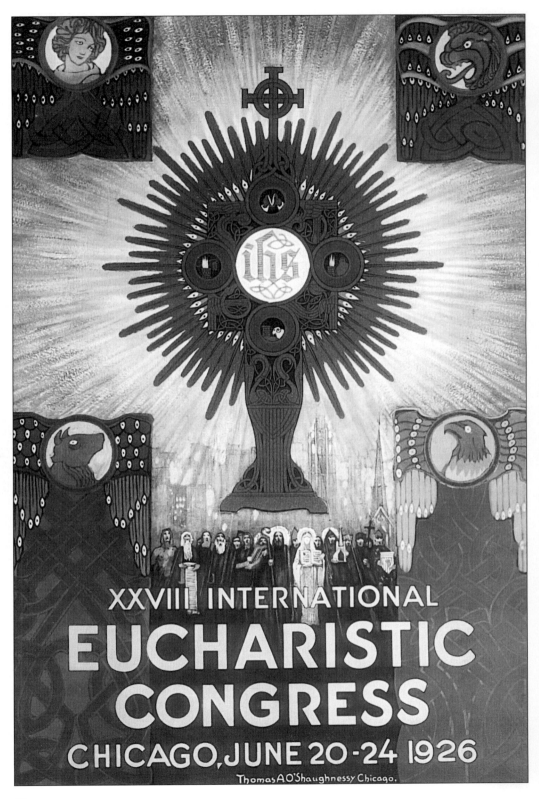

Above, Left: Another view of the monstrance Thomas O'Shaughnessy designed for the 1926 Eucharistic Congress, this one adorning the entrance of Holy Name Cathedral. (Photo courtesy of Tom Mescall.)

Above, Right: Young Andrew Greeley poses in a backyard in St. Angela parish on the West Side in the 1930s. The boy would go on to become, among other things, a priest, a sociologist and university professor, a scholar of the Irish diaspora, a newspaper columnist, and a bestselling novelist. (Photo courtesy of Rev. Andrew Greeley.)

Opposite: Thomas A. O'Shaughnessy was a major figure in the mid-19th to early-20th century artistic movement, now referred to as the Celtic Revival, that reclaimed ancient Celtic design for aesthetic and political ends. The windows and interior of the beautifully restored Old Saint Patrick's Church are the best remaining examples of his stunning interpretation of Celtic patterns and ornament, inspired largely by his hands-on study of the Book of Kells in Dublin in 1900. O'Shaughnessy's art was also fully integrated into the civic life of his day: he was the artistic director of the Irish Village at the 1933–34 Century of Progress World's Fair, he designed the programs for the yearly Irish Fellowship Club banquets, and he created the poster opposite for the 1926 Eucharistic Congress held in Chicago. (Photo courtesy of Mr. and Mrs. Joseph O'Shaughnessy.)

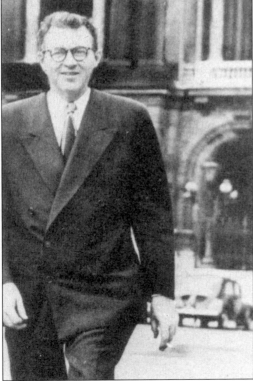

The legendary amusement park Riverview (at Western and Belmont) hosted an Irish Day on its grounds each year, drawing huge crowds. Attendance at the 1938 Irish Day was 30,000, with 60 girls vying for the crown in the Queen of Irish Day contest. These 1951 attendees, Mary Ann Kane, Kathleen McDermott, and Mary Ann Dalton, opted for hot dogs instead. (Photo courtesy of Archdiocese of Chicago's Joseph Cardinal Bernadin Archives and Records Center.)

In works like his *Studs Lonigan* trilogy, author James T. Farrell explored the lives of working- and middle-class South Side Irish Chicagoans in the first three decades of the 20th century. Farrell's early years in the Washington Park area provided him with experiences that the prolific writer mined throughout most of his career. Farrell scholar Charles Fanning describes him as a "pioneer in the field of urban ethnic literature," an American realist "committed to giving serious literary consideration to the common life." (Photo courtesy of Jay Robert Nash.)

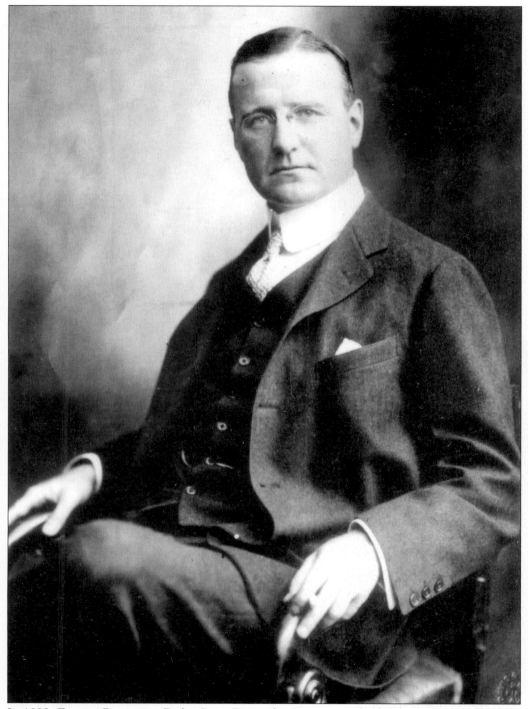

In 1893, *Evening Post* writer Finley Peter Dunne began a series of columns using the voice of a fictional Irish barkeep in Bridgeport, Mr. Dooley, to comment on day to day life in the neighborhood and the city. Over the course of 300 Mr. Dooley columns, Dunne created what author Charles Fanning calls "the first fully realized Irish ethnic neighborhood in American literature." (Photo courtesy of Chicago Historical Society, ICHi-10168.)

Of all the promotions of traditional Irish culture championed during the Irish Revival in the late 19th century, the Gaelic Athletic Association, formed in 1884, was the most popular. This 1926 photo of a Chicago hurling team proves that the sporting tradition survived the crossing. (Photo courtesy of Irish American Heritage Center.)

Aine Greene of Erin's Rovers Ladies Gaelic Football Club races downfield in GAA play at Chicago Gaelic Park. The park's impeccably tended fields are host to football, hurling, and camogie teams every Sunday during the summer months. (Photo courtesy of Eric Carlson.)

Eight

TO SERVE AND PROTECT

When Dr. Levi Boone was elected mayor in 1855 on a nativist, or anti-foreigner, platform, one of his first acts was to expand the city's police department to serve the growing population (by 1860 it would reach 100,000). However, native birth became a requirement for employment, thus excluding the large numbers of Irish and other immigrants who resided in the city. Ultimately, Boone's xenophobic politics—he infuriated immigrants further by passing legislation outlawing the sale of beer and liquor on Sunday—proved to be bad policy, and he served only one term as mayor. Four years later, by 1860, nearly half of the Chicago police force was Irish.

The number of Irish police at any given time in Chicago history is difficult to pinpoint, since ethnicity was never accounted for in records. While percentages may conflict, it is generally agreed that the Irish were by far the most well-represented ethnic group on the force. Anecdotally, the evidence is overwhelming. There are very few old Irish families in Chicago who do not have at least one, if not several, family members over generations who served as policemen. As Nicholas Carolan writes in *A Harvest Saved*, his biography of police chief Francis O'Neill, "Irishmen in Chicago saw policing as a natural route of advancement from labouring and other menial work, one which combined adventure with security."

The Clarke family of Chicago is a good example of service on the police force over generations. Michael Clarke and his brother Francis immigrated from County Cavan early in the last century and both joined the police force. Michael Clarke's two sons, Robert and John, also became policemen, the former rising to the rank of lieutenant. Of the current generation of Clarkes, two of Lieutenant Robert Clarke's children, Patricia and Martin, followed their father and grandfather into the profession (sadly, Martin died in an auto accident while on duty in 1984, after only a year on the force; Patricia is pictured in this chapter with the women of the Emerald Society).

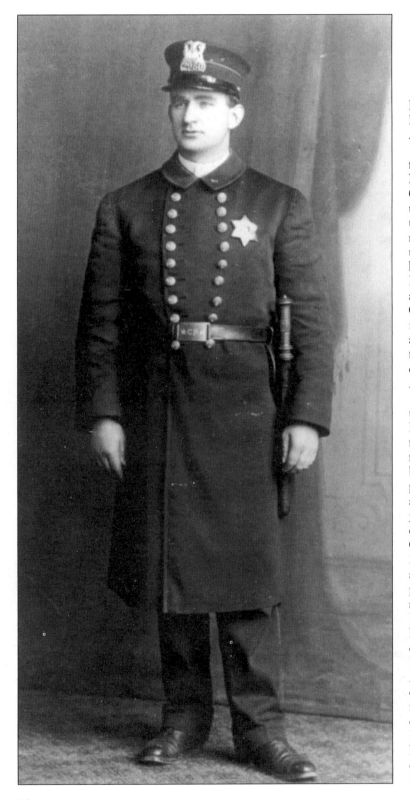

Patrick Francis Delaney's life in America began in 1902, when he sailed from Queenstown to New York on the *Germanic*. According to family legend, he traveled under the name Patrick Hickey to avoid arrest for having deserted the British army. After arriving, he settled in Chicago, did a stint in the U.S. Army, and married a girl from his native county of Tipperary, Annie Lonergan. In 1909, Delaney joined the Chicago Police Department. After a few years on the force, he paid for his brother Jeremiah's passage to the U.S. and Jeremiah Delaney joined the police department as well. In October 1929, after 20 years of service and an eventual promotion to sergeant, Patrick Delaney was shot and killed while patrolling on the West Side. He left behind his wife, Annie, and four children. His star, number 417, is still on display at Chicago Police Department headquarters. (Photo courtesy of Garnette Delaney.)

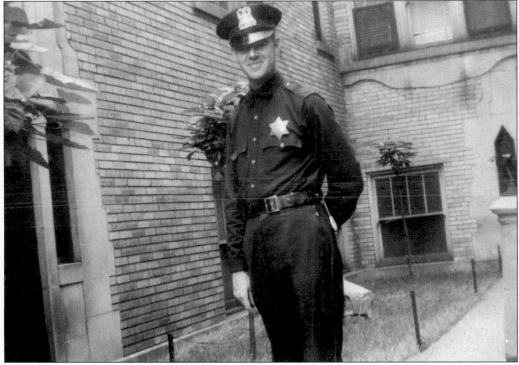

Only 14 years old when his father (Patrick Delaney, opposite) was killed in the line of duty in 1929, William Delaney remained undeterred in his dream to become a police officer. He is pictured here in the early 1940s, shortly after joining the force. Delaney spent 32 years in the Fillmore district. (Photo courtesy of the Delaney family.)

William Delaney Jr. and Robert Delaney are the third generation of Delaneys in the Chicago Police Department. William Jr., who inherited his father's star number, spent nearly 30 years on the force before retiring in 2001; Robert is currently a sergeant. (Photo courtesy of the Delaney family.)

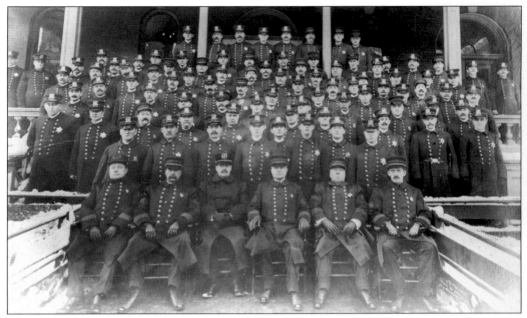

Police officers of the 11th District gather outside a public building for a group portrait sometime after 1910. (Photo courtesy of Bill King.)

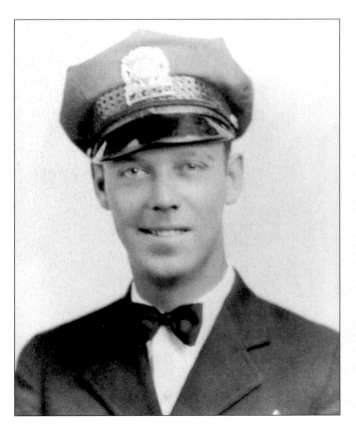

Young Matthew Ryan poses proudly in his uniform shortly after joining the Chicago Park District Police in the early 1930s. According to his daughter Mary Ellen Nedved, Ryan was so eager to join the force that he fudged on his age to meet the minimum age requirement for cadets. Until 1959, when the two agencies were merged, the Park District Police was a separate force whose officers patrolled the Chicago parks, boulevards, Soldier Field, and Lake Shore Drive. (Photo courtesy of the Nedved Family.)

John Joseph Fleming of Galway stands tall atop a tree stump outside Berg's Market in Rogers Park in the late 1920s. Fleming, a Chicago Police Department detective at the time of this photo, held jobs common to Irish immigrants of his day. After arriving on the *Lusitania* in 1912, he worked as a coal miner in Morris, Illinois, fought for the United States in World War I, became a motorman for the Chicago Surface Lines, and after retiring from the CPD, opened a tavern at Irving Park and Sheridan. (Photo courtesy of the Fleming family.)

Patrolmen Andy O'Donnell and Tom O'Brien knock back a few boilermakers after a day on the beat. (Photo courtesy of Mary Pat O'Brien.)

Tom Bolton and Chicago police officer Walter Philbin celebrate St. Patrick's Day at the Mort-Clark tavern in 1957. (Photo courtesy of Mary Kay Cappitelli.)

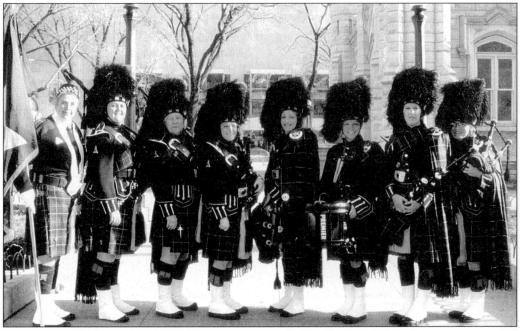

It wasn't until the early 1970s that women joined the Chicago Police Department as full officers, many of them becoming part of a family tradition on the force that included brothers, fathers, and uncles. They also took their place in the Bagpipes and Drums of the Emerald Society, as this photo shows. Pictured, from left to right, are Patricia Clarke, CPD; Linda Fogarty, CPD; Mary Jones, retired CPD; Stephanie Mack, Arlington Heights Police Dept.; Megan Flisk, CPD; Megan Griffin, CPD; Barb Flaherty, CPD; and Carla Weinbrenner, CPD. (Photo courtesy of the Emerald Society.)

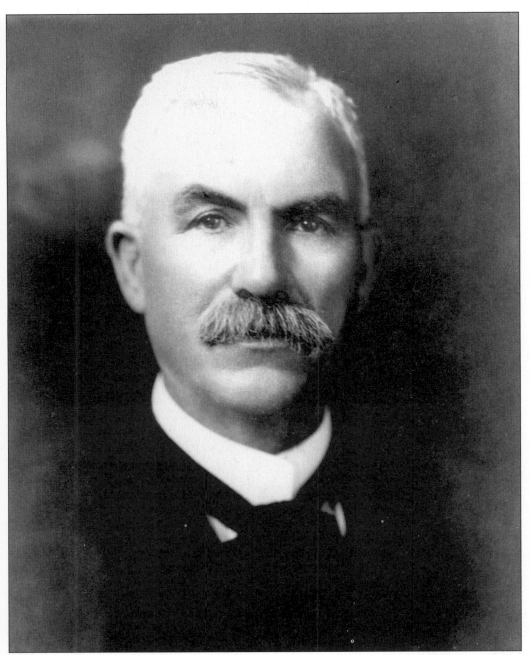

Francis O'Neill left Tralibane, County Cork, at the age of 16 for a life of adventure, sailing around the world and working as a shepherd in the Sierra Nevada Mountains before settling down in Chicago, where he joined the police department in 1873. His integrity and dedication through turbulent times in Chicago history led to several promotions, and he was eventually tapped for chief of police by Mayor Carter Harrison Jr., a post he held from 1901–1905. Besides this accomplishment of having reached the highest position possible in his career as a police officer, O'Neill will be remembered for his published collections of Irish music. By cataloging as many as 1,000 tunes, O'Neill and his associates (many of them police officers) preserved a legacy of Irish music for generations to come. (Photo courtesy of Noel Rice/Mary Lesch.)

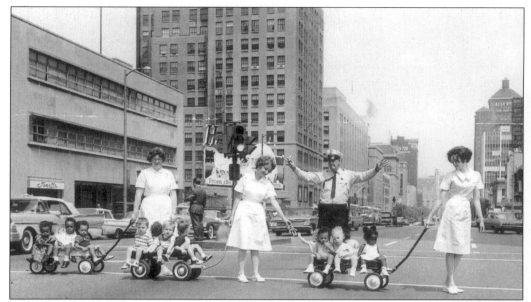

The author's father, Bernard F. McLaughlin, shepherds children and staff from St. Vincent's orphanage across Michigan Avenue around 1960. The son of immigrants from Donegal and Clare, McLaughlin fit the pattern of the Chicago-born Irish of his generation: baptized at St. Bridget on Archer Avenue, attended school at St. Patrick, followed his brother onto the police force, took the pledge at St. Carthage in the 1940s, and eventually retired to a life of backyard cigar smoking and gardening.

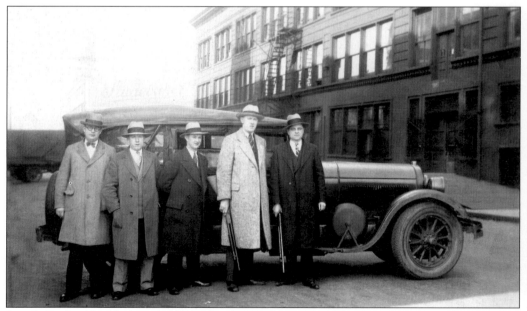

Joseph Burke (fourth from left) and his formidable team of detectives stand in front of their Cadillac sedan squad car in the 1920s. A car similar to the one pictured was used to fool the victims of the 1929 St. Valentine's Day Massacre into thinking that their warehouse was being raided by police. Instead, they were gunned down by Capone henchmen. (Photo courtesy of Dan McLaughlin.)

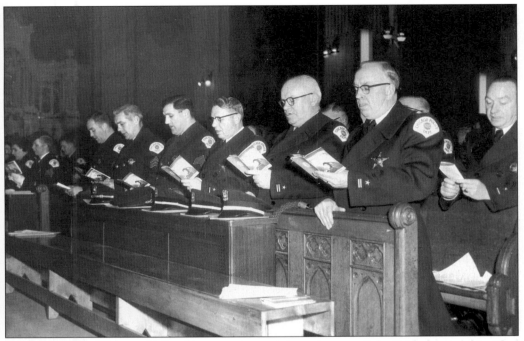

Members of the Chicago Police Department participate in one of the Friday novenas at Our Lady of Sorrows. (Photo courtesy of Our Lady of Sorrows Basilica.)

The Bagpipes and Drums of the Emerald Society pose in front of Holy Name Cathedral on the day of the 2000 St. Jude Memorial March. Founded in 1982 with the assistance of Mayor Jane Byrne, the band draws its membership from the Emerald Society, a fraternal organization of law enforcement officers of Irish descent. Although they have become a staple at parades over the years, the band's most important duty is to accompany the funeral of a police officer or firefighter killed in the line of duty. (Photo courtesy of the Emerald Society of Illinois.)

In this 1914 photo, officers Donahue, Sullivan, and Crowley pose with their horse-drawn paddy wagon in front of the Lawndale Station. In the days before sirens, a bell on the footboard alerted citizens to the presence of an emergency vehicle. (Photo courtesy of Special Collections and Preservation Division, Chicago Public Library.)

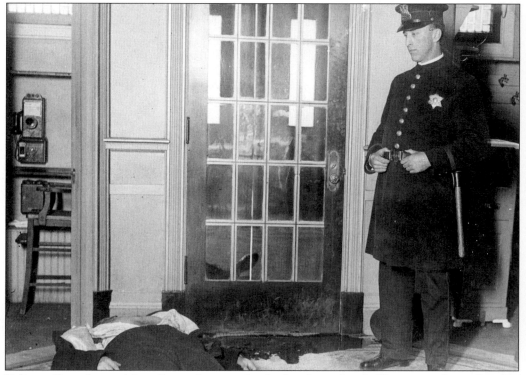

Police officer James Mescall stands over the body of murdered Chicago mobster Big Jim Colosimo at his South Wabash restaurant in 1920. Colosimo's demise coincided with the beginning of Prohibition and paved the way for the ascendancy of gangsters Johnny Torrio and Al Capone in Chicago. This was not Clare native Mescall's first witness to a historic Chicago event: on July 24, 1915, he was one of the first officers on the scene of the Eastland Disaster, when a crowded excursion steamer capsized in the Chicago River between Clark and LaSalle Streets, killing more than 800 people. (Photo courtesy of Tom Mescall.)

Nine

PARISH,
NEIGHBORHOOD,
AND COMMUNITY

When Chicagoan Sheila Dawson refers to particular North Side Irish parishes as "Turf," "Patch," and "Blacktop" in conversation, only a fellow Edgewater/Rogers Park Catholic could possibly understand that she is speaking about St. Gertrude, St. Ignatius, and St. Margaret Mary respectively. This sort of parochialism that would leave South or West Siders scratching their heads is not uncommon in a city with such a dispersed community as Chicago's Irish. After leaving their original 19th-century settlements along the river for neighborhoods across the city, the Irish founded parishes that became the geographic centers which, in author Ellen Skerrett's words, "reduced the awesome experience of urban life to a manageable scale." In this small world, social contacts often extended only as far as the parish boundaries. In neighborhoods that have remained unaffected by sweeping demographic changes, like the parishes mentioned above, or Nativity of Our Lord and Saint Gabriel on the South Side, it is not uncommon to find residents who have spent their entire lives in the same parish.

For generations, the parish structure provided a sense of cradle-to-the-grave comfort and community for Chicago Irish. When social mobility lured the growing middle class to neighborhoods further north, west, and south of downtown, they built parishes and schools similar to the ones they left behind. To some degree, the parishes even survived the exodus of Chicago's Irish to the suburbs.

However, as the Catholic Church's influence has lessened in recent decades, Chicago-area Irish have seen a loosening of the traditional ties that once bound them as a ethnic group. The establishment in the mid-1980s of Gaelic Park on the South Side and the Irish American Heritage Center on the North Side may have been an indirect attempt to create a focus for a changing community, one more attuned to the renewed interest in Irish music, dance, sport, literature, and theater.

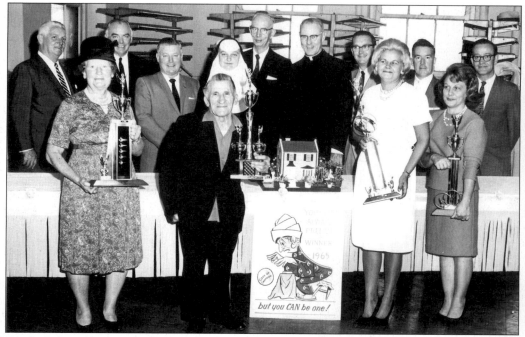

South Side politicians and religious leaders take a moment to share a photo-op with award-winning Canaryville gardeners in 1965. Pictured in the back row, from left to right, are Ald. Joe Burke, John B. Wheeler, Judge Joseph Power, Sister Mary Coletta, RSM, unidentified Protestant minister, Rev. Peter Reilly, Ald. Matt Danaher, Richard Grace, unidentified. (Photo courtesy of St. Gabriel Parish.)

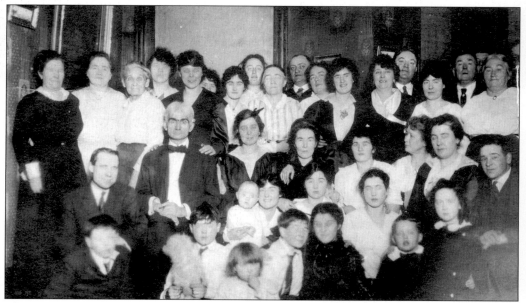

The entire neighborhood appears to have been invited to Katherine Doran's engagement party in 1918. The festivities were held around Kedzie and Polk streets, with the betrothed standing top, twelfth from left, resting her arm on her mother's shoulder. (Photo courtesy of Pat Slapinski.)

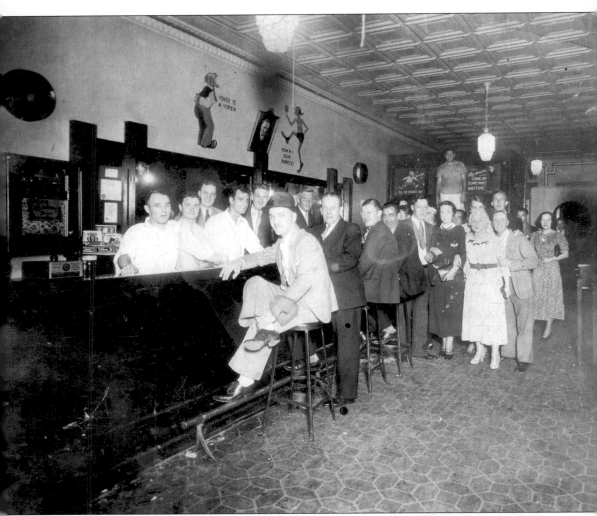

Sparely decorated with the icons of the day—Franklin Delano Roosevelt, Popeye, and Mae West—the Panel Inn on 75th Street in South Shore attracted an Irish clientele, but like most taverns of its kind, had none of the markers that signify an Irish bar today. In this 1935 portrait, owner Pat King stands behind the bar on the far left. (Photo courtesy of Bill King.)

Donning the coat and hat of a young soldier friend, Margaret Moran gets into the spirit for her job selling war bonds in 1916. The daughter of a policeman, Moran began teaching in the public schools a few years later, and eventually became a principal. (Photo courtesy of Rita Wogan.)

Rev. Howard Doherty smiles approvingly as Phil Regan, a 1930s and 40s radio star known as "the singing cop" for his early days as a New York City detective, signs autographs for adoring Mercy High School fans. The Irish-American tenor appeared at the school as part of a World War II victory bonds rally. His fans are (from left) Isabelle Keegan, Beverly Little, Kathleen Gaughan, Pat McCormick, and Jean Foley (beside Regan). (Photo courtesy of Archdiocese of Chicago's Joseph Cardinal Bernadin Archives and Records Center.)

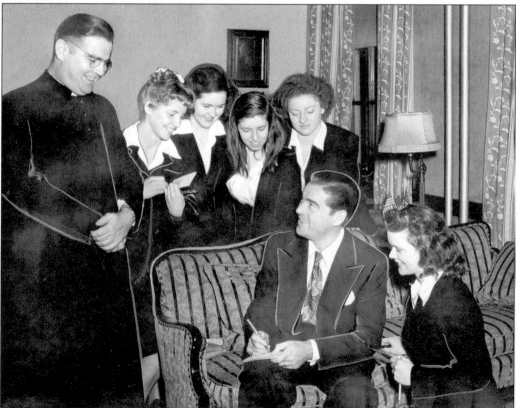

This talented priest, stepping up to the microphone to entertain wedding guests while the band takes a break, looks the very model of the Irish priest popularized in mid-century films by such actors as Bing Crosby and Spencer Tracy. (Photo courtesy of Irish American Heritage Center.)

After World War II, commemorative posts honoring soldiers who lost their lives in the conflict sprung up in neighborhoods around the city. The post at the corner of Augusta and Lawler was dedicated to Daniel V. Carrigan, a resident of that block who was killed in action. Jim and Tom Kane stand in front of the post while Carrigan's brother Willie stands beside it. (Photo courtesy of Jim Kane.)

Eddie Duffy draws a beer at Connolly's in the 1970s. Duffy, a Chicago Fire Department captain, co-owned the popular Devon Avenue tavern with accordion-playing partner Mike Connolly. (Photo courtesy of Ed Duffy.)

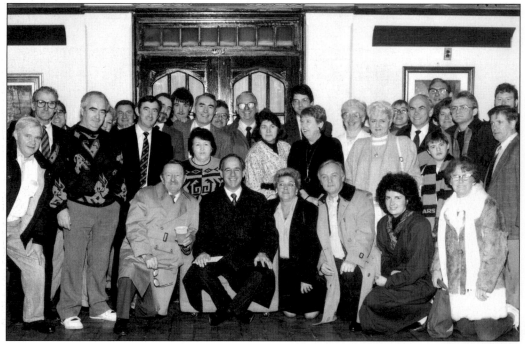

Since its opening in 1985, the Irish American Heritage Center has hosted many visiting Irish dignitaries, including Dublin's Lord Mayor Ben Briscoe (seated) in 1988. Briscoe is surrounded by members of the Dublin Association, a social group of Dublin natives and friends that has been meeting for over 40 years. (Photo courtesy of Irish American Heritage Center.)

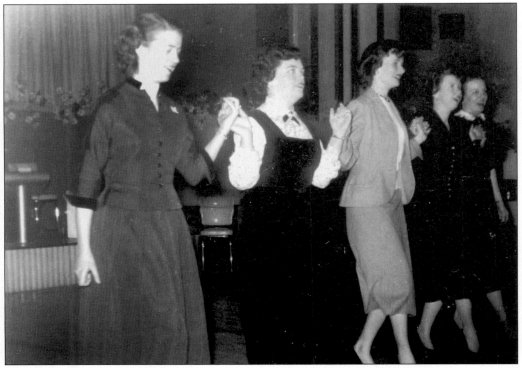

Even with the days of competition and performance long behind them, former dancers can still be expected to entertain a bit at weddings and other large gatherings. (Photo courtesy of the Fahey family.)

"*Everybody* knew Eileen O'Connor," remembers Nora Teahan, recalling one of Irish Chicago's most gregarious personalities. Pictured here with popular Irish tenor Joe Feeney from the Lawrence Welk television show, the ever-smiling O'Connor was an indefatigable fundraiser and early supporter of the Irish American Heritage Center. (Photo courtesy of Irish American Heritage Center.)

Marion Kennedy Volini, pictured here enjoying a moment with Mayor Jane Byrne, was only the third woman to be elected to the office of alderman in Chicago. Originally from the South Side neighborhood of St. Rita, Volini later settled in the Lakewood Balmoral area on the North Side. Her leadership in community organizing led to her election in 1978 as alderman of the 48th Ward, a post she held until 1987. (Photo courtesy of Woman and Leadership Archives of the Ann Ida Gannon, BVM, Center for Women and Leadership, Loyola University Chicago.)

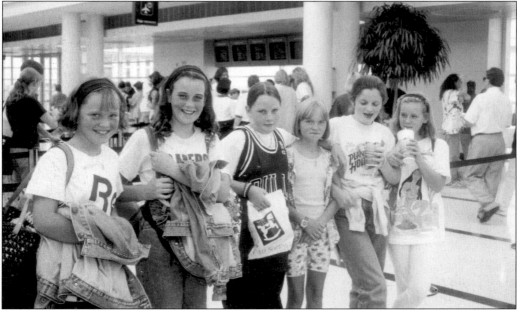

Each summer, Chicago area families wishing to make a positive contribution to reconciliation in Northern Ireland host approximately 150 Belfast children and teens for a five-week long holiday. The program, called The Irish Children's Fund, brings young people from both Catholic and Protestant communities together for summer outings and relaxed interaction, with the modest hope that friendships begun here can help further understanding in the future. In this 1997 photo, girls shop for some last minute souvenirs at O'Hare Airport before boarding a plane for their return to Belfast. (Photo courtesy of the Conway family.)

The Shannon Rovers provide musical accompaniment for Gaelic Athletic Association games at Shewbridge Stadium at 79th and Aberdeen in the late 1950s. Rovers founder Tommy Ryan is second from left, and Irish radio host Maureen O'Looney (far left) is part of the roster for the women's camogie team. (Photo courtesy of Jim Kane.)

The music and socializing stops just long enough for everyone to pose for a picture at this 1949 gathering in the basement of the O'Connor home. The occasion was a planning party for a yearly fundraiser for the Catholic missions. Note that no matter what the venue—basement or ballroom—people always dressed for a night out. (Photo courtesy of the Fahey family.)

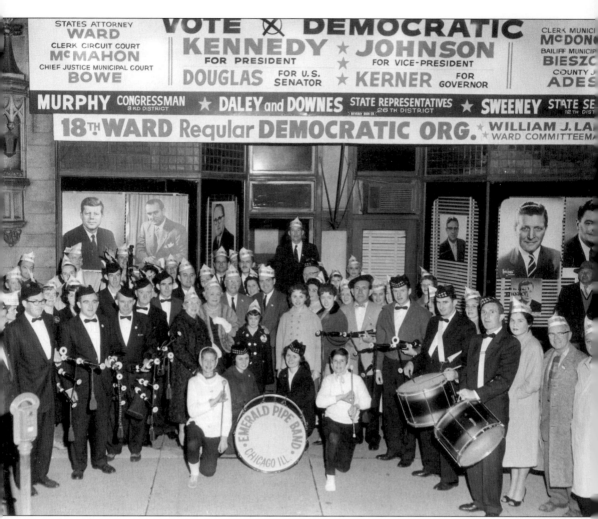

The Emerald Pipe Band lends its support to the historic 1960 Democratic ticket that resulted in the election of the first Irish-Catholic president of the United States, John F. Kennedy. As the billboards at the 18th Ward Democratic Office on Laflin and 79th Street make clear, there was no shortage of local Irish politicians on that year's slate. (Photo courtesy of Dan McLaughlin.)

Ten

SAINT PATRICK'S DAY

The first celebrations of St. Patrick's Day in Chicago began shortly after the Irish started arriving in the city in the 1830s. Eileen Durkin's essay, "St. Patrick's Day at St. Patrick's Church," from *At the Crossroads*, describes the early holidays as both religious and festive, beginning with high masses said by Bishops Quarter or Van de Velde and followed by a march. As the city's Irish population increased during and after the famine, the parades got bigger, longer, and more politicized, fueled by continued English intransigence on the issue of Irish independence.

Compared to today's parades, the 19th-century marches were more like marathons, stretching from Chicago Avenue to 18th Street north to south, and from Wabash to Ashland east to west—nearly six miles. As anyone who has ever attended a St. Patrick's Day parade knows, the weather doesn't always cooperate. According to Durkin, so many elderly marchers died of pneumonia in the 1890s that the parade was discontinued in 1902.

Even without a parade, the Irish in Chicago continued to celebrate St. Patrick's Day. Parishes observed the holiday with masses, fraternal organizations held parties for their members, and the Irish Fellowship Club, founded in 1901, began its yearly tradition of St. Patrick's Day banquets. People celebrated in the neighborhoods as well. Kathleen Gaughan has fond childhood memories of the parties her Irish-born parents used to throw for neighbors in the basement of their apartment building in St. Bernard's parish in Englewood.

In the early 1950s, parades made a comeback. The Irish of the West Side marched on Madison Street, while the South Siders paraded down 79th Street. The year after Richard J. Daley became mayor in 1955, he brought the procession downtown again, to State Street. After the smaller marches merged with the State Street event, the neighborhoods were without a celebration of their own until 1979, when the South Side Irish Parade began anew. It was only a matter of time until the suburbs began to host parades as well: Elmhurst, Naperville, Tinley Park, Forest Park, and St. Charles have all established the tradition in recent years.

Today, St. Patrick's Day observations hold something for everyone. Revelers who want to dive into "amateur night" will find plenty of nightspots where green beer and shamrock antennae can be found in abundance. More cerebral pleasures can be had at cultural institutions around town; on one night during St. Patrick's week 2001, for example, fiddler Liz Carroll and writers Colm Toibin and Fintan O'Toole appeared at the Harold Washington Library, followed by a reading in Old Town by Patrick McCabe (*The Butcher Boy*). Of course, traditional music can be heard at any number of venues around town, with nightly concerts at Gaelic Park and the Irish American Heritage Center in the days approaching the holiday.

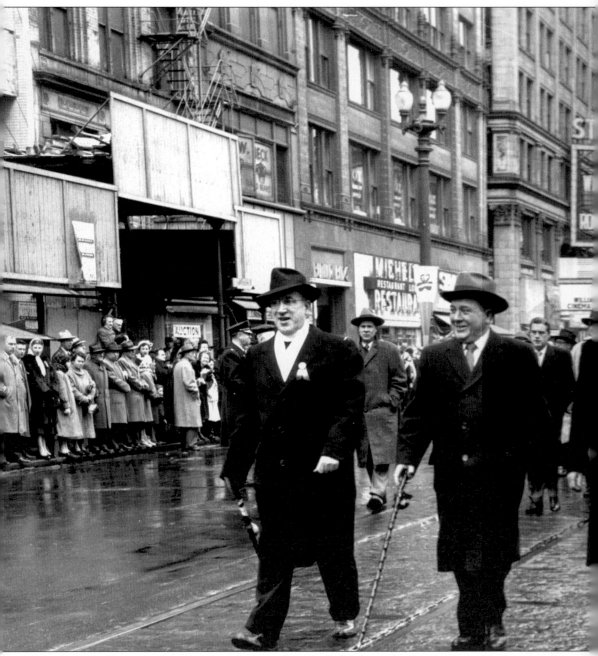

After a half century of absence, Mayor Richard J. Daley brought the St. Patrick's Day parade downtown again in 1956. The day is appropriately gray and wet, and the uncomplicated front

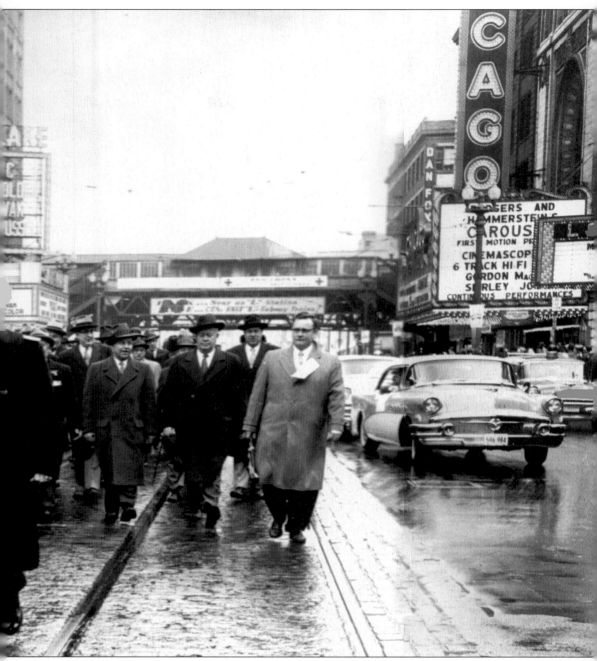

line is free of green kitsch, as are the spectators. (Photo courtesy of Irish American Heritage Center.)

What began as an informal children's march around the block in 1979 has grown into a much anticipated yearly tradition—the South Side Irish St. Patrick's Day Parade. The day begins with a mass at St. Cajetan Church and is followed with a march from 103rd to 115th Street on Western Ave. In this 2001 photo, young dancers keep their legs moving to ward off the chill. (Photo courtesy of Don Bowman.)

A charter member of Hollywood's Irish Mafia along with James Cagney, Spencer Tracy, and Frank McHugh, actor Pat O'Brien (top left) cuts up at the 1968 St. Patrick's Day Irish Fellowship Club dinner. Sharing the laugh are (clockwise from top) Bob Considine, Patrick O'Malley, and Mayor Richard J. Daley. (Photo courtesy of Archdiocese of Chicago's Joseph Cardinal Bernadin Archives and Records Center.)

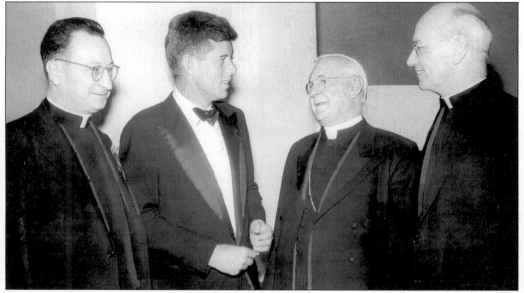

Thirty-nine-year-old Massachusetts Sen. John F. Kennedy was the keynote speaker of the St. Patrick's Day 1956 Irish Fellowship Club dinner at the Sherman Hotel. With Kennedy are Rev. Edward Kammer of DePaul University, Samuel Cardinal Stritch, and Rev. James Maguire of Loyola University.

Members of the Connaught Men's Social Club celebrate St. Patrick's Day at the Mont-Clark Tavern (Montrose and Clark Streets) in 1958. After marching behind the club banner in the downtown parade, the group continued the festivities at fellow Connaught native Martin T. Murray's bar. Posing under the Erin go Bragh banner are Jack Bresnahan and Walter Philbin (seated), Martin Murray, Martin T. Murray, proprietor, and John Dougherty (standing). (Photo courtesy of Mary Kay Cappitelli.)

Every St. Patrick's Day parade has its queen. Looking regal and refined beyond her years, Mother McAuley high school student Patti McLean won the honor in 1961. Included in her court were fellow high schoolers Betty Howlett, Jean Campbell, Nancy Kerrigan, and Diane Duffy. Stephen M. Bailey of the St. Patrick's Day Parade Committee was the lucky man crowning the queen. (Photo courtesy of Archdiocese of Chicago's Joseph Cardinal Bernadin Archives and Records Center.)

Displaying his usual lack of ostentation, Mayor Richard J. Daley rides in the South Side St. Patrick's Day Parade in the late 1950s, with 18th Ward Committeeman William J. Lake seated to his left. This 1950s precursor to the Western Avenue parade marched down 79th Street from Ashland to Halsted and terminated at St. Sabina church. After Mayor Daley revived the downtown parade in 1956, the South Side parade continued on for a few more years until finally ending in 1960. (Photo courtesy of Dan McLaughlin.)

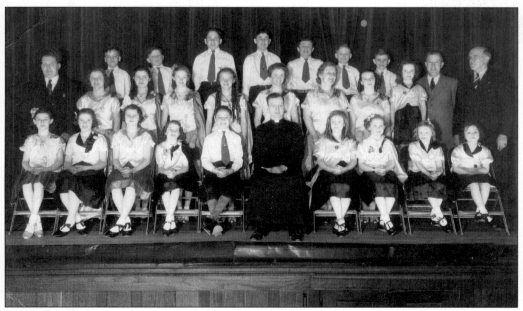

For the better part of a century, the congregation of St. Gabriel parish has celebrated St. Patrick's Day with dances and plays. Here, a group of dancers pose with Rev. Michael J. Sweeney in the school auditorium on March 17, 1936. Even today, the neighborhood is decorated with Irish flags and shamrocks come early March. (Photo courtesy of St. Gabriel Parish.)

The Drovers hang out backstage before a performance at Metro on March 17, 1993. Formed in the late 1980s, the band shook up the Irish music scene in Chicago with their electric, American-filtered interpretation of traditional Irish styles. A combination of outstanding performances and dramatic personnel changes has kept fans and scene watchers engaged for years. Pictured here, from left to right, are Winston Damen, Dave Callahan, Mike Kirkpatrick, Jackie Moran, and Sean Cleland. (Photo courtesy of Paul Natkin.)

The city's 2002 St. Patrick's Day Parade marked the first time a serving United States president led the marchers. Heading up the parade with George W. Bush (center) were Gerald Sullivan of Local 130 Journeyman Plumbers Union, Mayor Richard M. Daley, Gov. George Ryan, and Mary Hanafin, the Republic of Ireland's Minister of Health. The parade also honored the memory of Rev. Mychal Judge, the FDNY chaplain who died in the World Trade Center attacks. (Photo courtesy of St. Patrick's Day Parade Committee.)

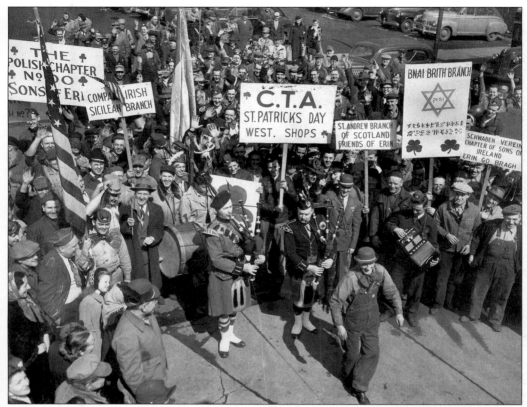

The parade of nationalities at the CTA West Shops on March 17, 1949, proves the saying that "On St. Patrick's Day, everyone is Irish." (Photo courtesy of Special Collections and Preservation Division, Chicago Public Library.)

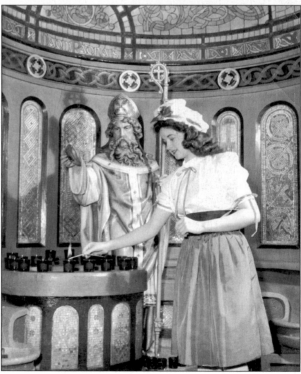

A costumed young woman lights a candle to Ireland's patron saint at Old St. Patrick's Church. (Photo courtesy of Historical Archives of Old St. Patrick's Church.)

One St. Patrick's Day tradition in Chicago is the formal presentation to the mayor of an invitation to the annual parade. In 1972, young champion Dennehy dancer Mark Howard—festooned with competition medals, autograph book in hand, and accompanied by his father, Michael—was given the honor of inviting Mayor Richard J. Daley to the festivities. Less than a decade later, Mark established his own school, the Trinity Academy of Irish Dance. While appreciative of the fame and accolades his son and Trinity have gone on to win over the years, the 1972 meeting with Mayor Daley remains one of father Michael Howard's proudest moments. (Photo courtesy of Trinity Academy of Irish Dance.)

Lest anyone needs reminding, a
dancing pint works the crowd along
Western Avenue on parade day.
(Photo courtesy of Don Bowman.)

For over a quarter century, The Young Irish Fellowship Club of Chicago has been supporting
charities and Chicago Irish cultural organizations with the proceeds from their yearly St.
Patrick's Day bash, Forever Green. Above, a young Irish fellow at the 1987 revels signals his
approval of the music. (Photo courtesy of the Young Irish Fellowship Club.)

SUGGESTED READING

Carolan, Nicholas. *A Harvest Saved: Francis O'Neill and Irish Music in Chicago*. Cork, Ireland: Ossiar Publications, 1997.

Duis, Perry R. *The Saloon: Public Drinking in Chicago and Boston, 1880–1920*. Urbana and Chicago: University of Illinois Press, 1999.

Edelstein, T.J., ed. *Imagining an Irish Past: The Celtic Revival 1840–1940*. Chicago: The David and Alfred Smart Museum of Art, The University of Chicago, 1992.

Fanning, Charles. *Mr. Dooley and the Chicago Irish: The Autobiography of a Nineteenth Century Ethnic Group*. Washington, D.C.: Catholic University of America Press, 1987.

Fanning, Charles, ed. *New Perspectives on the Irish Diaspora*. Carbondale, Illinois: Southern Illinois University Press, 2000.

Fanning, Charles, Ellen Skerrett, John Corrigan. *Nineteenth Century Chicago Irish: A Social and Political Portrait*. Chicago: Center for Urban Policy, Loyola University of Chicago, 1980.

Holli, Melvin G., and Peter d'A. Jones, eds. *Ethnic Chicago*. Grand Rapids, Michigan: William B. Eerdmans Publishing Company, 1984.

Lane, George, and Algimantas Kezys. *Chicago Churches and Synagogues: An Architectural Pilgrimage*. Chicago: Loyola University Press, 1981.

McCaffrey, Lawrence J., Ellen Skerrett, Michael F. Funchion, Charles Fanning. *The Irish in Chicago*. Urbana and Chicago: University of Illinois Press, 1987.

McMahon, Eileen M. *What Parish Are You From? A Chicago Irish Community and Race Relations*. Lexington, Kentucky: The University Press of Kentucky, 1995.

Pacyga, Dominic A., and Ellen Skerrett. *Chicago: City of Neighborhoods*. Chicago: Loyola Press, 1986.

Skerrett, Ellen, ed. *At the Crossroads: Old St. Patrick's and the Chicago Irish*. Chicago: Wild Onion Books, 1997.

Wade, Louise Carroll. *Chicago's Pride: The Stockyards, Packingtown, and Environs in the Nineteenth Century*. Urbana and Chicago: University of Illinois Press, 1987.